Through Your Eyes

Through Your Eyes

dialogues on the paintings of Bruce Herman

G. Walter Hansen | Bruce Herman

WILLIAM B. EERDMANS PUBLISHING COMPANY

GRAND RAPIDS, MICHIGAN / CAMBRIDGE, U.K.

Published 2013 by

Wm. B. Eerdmans Publishing Co.

2140 Oak Industrial Drive N.E., Grand Rapids, Michigan 49505 /

P.O. Box 163, Cambridge CB3 9PU U.K.

www.eerdmans.com

Printed in the United States of America

17 16 15 14 13 7 6 5 4 3 2 1

ISBN 978-0-8028-7117-6

Book design by Rebecca Powell

Contents

Foreword

"We had the experience but missed the meaning," observes T. S. Eliot in *Four Quartets*. And it is a longing to express this ineffable meaning, Bruce Herman tells us, that drives him to the art and act of painting. In his words, human life is an "ongoing 'ordinary' miracle, yet much of that miracle is not susceptible to verbal description." So he paints, "always trying to evoke those aspects of our experience that refuse to be said." In painting, "I am . . . 'translating'—that is, trying to express something that is essentially impossible to articulate verbally." To be an artist is to persist in the effort to "get at that side of experience where words must fail."

But even when the words fail, the silence of our experience summons us to speak and to seek the meaning we have missed. In Eliot's words, we strive to divine what those "moments of happiness" meant, when a "sudden illumination" flooded our darkened minds and hearts. When we embark on our search, we discover that our "approach to the meaning restores the experience," but "in a different form," one that carries us far "beyond any meaning / We can assign to happiness."

This book, whose pages you are about to see and read, is a sign of our good fortune that Bruce did not stop at the point at which words fail and experience goes silent. Instead, with the insightful prodding and encouragement of Walter Hansen, he persists in his efforts to articulate exactly what it is that he does when he tries to give voice to the inexpressible, through the speech of oils and gold leaf, canvas and board and wood.

As you read this book, and move from painting to commentary to reflection and back again, you will see and hear about the meaning of those "ongoing ordinary miracles" of which Bruce writes. *Through Your Eyes* is filled with stories of beauty and brokenness, told by Bruce through paintings that evoke Christ's sorrow over the destruction of Jerusalem, the collapse of Rome, and the corrosive, soulless powers of the modern city.

The paintings speak of brokenness, and so does their own history, in an uncanny way. If you look closely at the informational tags for the paintings, you will occasionally come across the following:

> But even when the words fail, the silence of our experience summons us to speak and to seek the meaning we have missed.

fig. 1. surface detail: *Prospero's Tempest* © 2010 Bruce Herman; oil on wood with silver leaf; 60" × 70"

"destroyed in studio fire, 1997." On September 12 of that year, a catastrophic blaze consumed the Herman family home, Bruce's studio, and most of the family's belongings, including nearly all of Bruce's unsold paintings. Then, years later, a different fate struck another of Bruce's paintings: on a Good Friday, Walter and Darlene Hansen's movers accidentally discarded a Herman painting, stored in a wooden crate they thought empty, in a landfill near Rockford, Illinois.

The story does not end there, either for the paintings or for the longing and brokenhearted world they render. Walter Hansen explains, "On Easter Sunday, Resurrection Day, we acquired *Betrothed* [a painting similar to the lost one] from the artist. The image sown in dishonor was raised in glory." In like manner, Bruce describes how it was that "out of the ashes" of his house and studio fire, he "found beauty by making paintings that dealt with the 'already and not yet' aspect of God's coming kingdom—the simultaneous ruination and hopeful redemption that this broken and bruised world can sometime evoke."

It strikes me that this is the animating theme that courses throughout the whole of *Through Your Eyes.* In these paintings and in the conversations they generate, we see and hear of new cities, new lives, and new meanings that rise out of the ashes and ruins of human folly and failure. Yet they rise not of their accord, but through the power of the One who raised Christ Jesus from the dead.

This theme is depicted with stirring power in one of Bruce's paintings, *Rome: A Vision,* to which he and Walter devote a good deal of their conversation. Walter interprets the bent-over figure at the center of a scene of ruins as Jesus Christ, whose form,

we learn from Bruce, is patterned after William Blake's famous etching of Isaac Newton some two centuries ago. Blake's *Newton,* in Bruce's words, "is a problematic, ambiguous figure. He is both an ideal man and . . . a symbol of futility" who remains oblivious to the "beauty and mystery of the world around him." In contrast, in *Rome: A Vision,* the figure of Christ weeps over the ruins of human civilization, even as he "bends to the earth not to measure but to embrace and touch the raw material of a new city."

Buried among the ruins that Christ reaches down to embrace and reform are, among myriad other things, the meanings of our individual experiences of sin, sorrow, and loss. When I had finished viewing the images and reading the dialogues within this book, a quietly moving passage from Dietrich Bonhoeffer's prison letters came to mind. It comes near the end of a long letter he wrote to his close friend and associate Eberhard Bethge over the course of two days in December 1943.

In that letter, as a son, brother, friend, and betrothed man, Bonhoeffer wrote of the pain of being "forcibly separated for any considerable time from those whom we love." We are repelled by the thought of substitutes, he says, and "we simply have to wait and wait . . . and feel the longing till it almost makes us ill." When we submit ourselves to such a discipline of longing, God assures us "that nothing that is past is lost," for he "gathers up again with us our past" and "holds it ready for us."

What this means, Bonhoeffer tells Bethge, is "that nothing is lost, that everything is taken up in Christ," through whom all things are "transformed, made transparent, clear, and free" from sin. "Christ restores all [things] as God originally intended

[them] to be," and he does so by removing all the distortions that are a product of our sin. This "doctrine derived from Eph. 1:10—that of the restoration of all things—is a magnificent conception, full of comfort," he concludes.

Our experiences and the meanings we seek to derive from them, our works of art and our ceaseless cultural labors, our efforts to build our cities, raise our families, heal the sick, and bring mercy to the downtrodden—all of these things and more—have been taken up in Christ, who, having gathered and restored them, holds them ready for us unto the last. These are the mysteries that Bruce Herman's works so vigorously explore and embody,

and they are the meanings he and Walter Hansen persistently seek, as they reflect respectively upon the act of painting and the experience of perceiving these works. Of their efforts, and of all such strivings by Christian artists, musicians, actors, and writers, may we, echoing Saint Paul (2 Cor. 9:15), simply say, "Thanks be unto God for such unspeakable gifts!"

Roger Lundin

Wheaton, Illinois
March 5, 2013

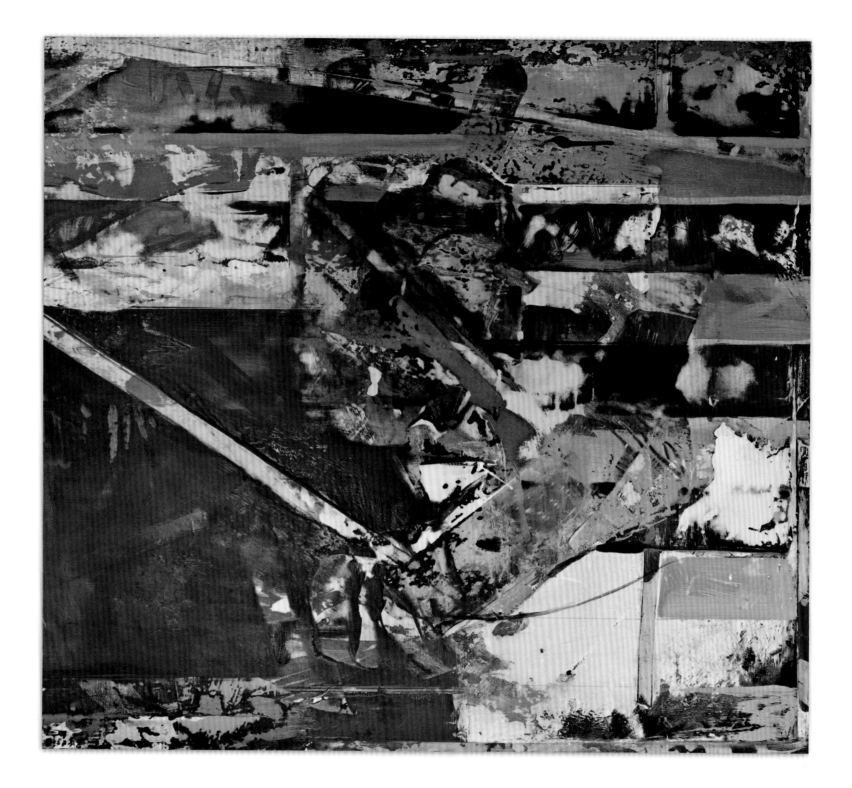

Introduction

The painter's continual search is for a place to welcome the absent. If he finds a place, he arranges it and prays for the face of the absent to appear.
—John Berger, *The Shape of a Pocket*

It was becoming ever clearer to me that it was not the pictorial image that I was seeking, but home for my restless and rebellious soul.
—William Congdon and Joseph Ratzinger (Pope Benedict XVI), *The Sabbath of History*

In the 1990s I was on my way to becoming a senior leader in a relatively large ministry organization. Though not unreasonable, the duties assigned to me were considerable, and I struggled to keep pace with my ever-increasing management responsibilities. Becoming a successful manager meant forgoing other opportunities that felt more life-giving, and as the months passed, my tangible connection to the University of Wisconsin–Madison, where I had once served as a campus minister, grew ever more dim. More distant still were my graduate studies in painting and drawing at Cranbrook Academy of Art. I continued to dutifully report to my small office in our organization's national headquarters, but I now see that my creative self was withering.

One morning while I was at my desk, a close friend phoned. Speaking with Jay is a welcome event in any circumstance, but her call to me that day was unexpected.

Wasting no time, she inquired, "What's going on?"

"Why do you ask?" I replied.

"Well, early this morning God woke me up to pray for you."

Jay paused and then went on to explain that during her morning meeting with God she had a very clear sense that I was struggling to be in my office. I readily admitted that this was the case. We talked a bit further and then, near the end of our conversation, she presented me with an assignment: "After we finish talking, take a few minutes to see if you can figure out where Jesus is in your office." It was an arresting mandate, to say the least.

Strangely, inexplicably, the answer to her question was close at hand. "Jesus" was immediately present to me on a postcard positioned on the wall above my desk. The image on the card—an exhibit announcement sent to me by artist Bruce Herman—was a painting of the Man of Sorrows titled *The Flogging* (1991)

fig. 2. *Mapping Midnight* © 2007 Bruce Herman; oil on board, 23" × 23"; collection of Cameron and C.K. Anderson

and rendered in pastels (see fig. 3). Amid my administrative torpor, that small reproduction summoned me to a still point wherein I was assured of Christ's presence. In that moment, the image became icon-like as it drew me to older depictions of Christ's Passion and images of Gospel accounts stored up in my mind's eye.

I cannot know how you, my reader, will regard this report. Some may find it overly subjective, mystical, or just weird. Perhaps it was insomnia or spicy food that stirred my friend to leave her bed in that early hour, not the Holy Spirit's prompting. Meanwhile others will consider the exchange *de rigueur* in a universe that, to their way of thinking, offers abundant opportunity to hear God's still, small voice. Whatever your response, the phone call, the question, and my quick turn to Bruce Herman's image is what transpired, and for me it underscores the transparency of spiritual friendship, the unpredictability of prayer, and the enduring power of art.

This, then, was an early and meaningful connection to the work of my good friend Bruce. From this vantage point, join me in considering three matters that undergird and encompass the whole of his work and life: meaning, iconography, and beauty.

Bruce Herman believes (as do I) that our cosmos was created and is sustained by a living God. Just as Romans 1:20 insists, Creation—the physical universe made by God—bears witness to the eternal nature and divine power of its Maker. It follows that the stuff of our world bears meaning. Based on its appearance, function, and provenance, each object possesses a particular history that is assembled over time. When objects perform their function well, our estimation of their value increases; and when

they fail to do so, we recycle or abandon them. Put differently, the objects that we fashion exist in an economy. And here it is worth pointing out that the oft-vaunted and largely modernist division between utility and aesthetics fails to capture the larger bearing of these things in our world. In fact, these more routine appraisals should prompt deeper reflection on two realities foundational to the whole human culture: the capacity of the material world to bear meaning and the character of our engagement with it.

Almost without exception, objects—their material form and provenance—advance a story. This is surely the case with *The Flogging*. Bruce's Golgotha series depicts what Gordon College colleague Dan Russ describes as the "flesh-and-blood Jesus." In other words, this image by Bruce Herman continues the tradition of portraying the suffering Christ—a theme that first appeared in fifth-century carvings and was reiterated by nearly every master painter and etcher in Western art for more than a millennium. Etchings by Rembrandt and Dürer and paintings by Giotto, Masaccio, Titian, and El Greco all come to mind, and within this genre, Matthias Grünewald's *Isenheim Altarpiece* (c. 1515) may be among the most poignant. *The Flogging* belongs to this long history of representation, this vast index of powerful images that recount the gospel message in fresh ways and to each generation. These works tell and retell the story of Christ's suffering, his body broken for us. In response we are invited to approach our own emptiness, absence, and wanting in hope.

Generally speaking, few will resist the idea that our material world is meaning-laden. Nonetheless, some Christian traditions find this assertion problematic. They wrongly imagine that the material world is the root cause of worldliness and go on

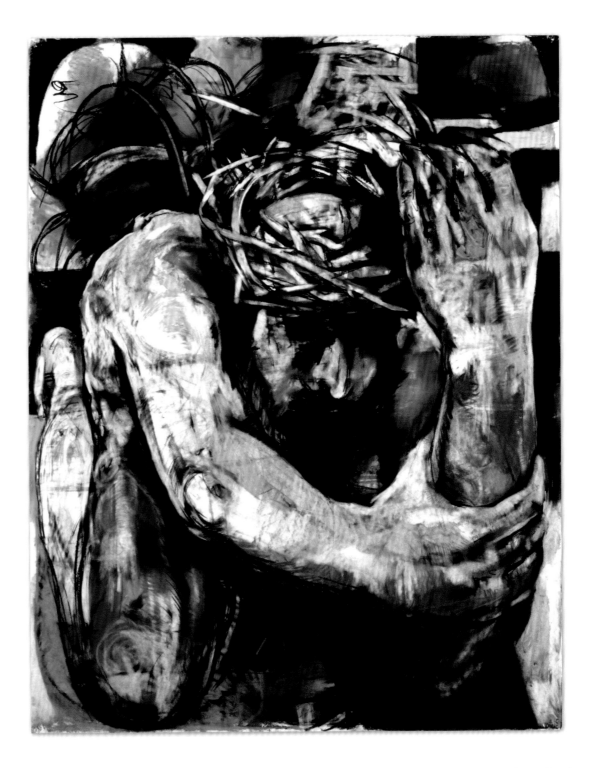

fig. 3. *The Flogging* © 1991 Bruce Herman;
pastel and mixed media on handmade
Dutch cotton paper; 60" × 46"; collection
of Rodney Peterson

to imagine that true spirituality is non-material. It is as if the doctrines of creation and incarnation have no bearing on matters of sin and salvation. But this bifurcation between the material and the spiritual is both unfortunate and mistaken. By virtue of their creation, all things (not just art) possess the capacity to bear meaning. And contrary to gnostic beliefs, Christians hold to the radical conviction that objects, spaces, relationships, and events exist according to some purpose.

God's world is filled with signs that both evidence his real presence and hint at the true future that awaits us. Because of this—and contrary to the arguments, say, of secular existentialists early in the twentieth century or postmodernists nearer to its end—humanity's great challenge is not to discover some scrap of meaning in an otherwise incoherent universe, but rather to become full participants in a world abounding in meaning, to embrace the overload.

Now let's consider my second point concerning the character of our engagement with this world: our vocation. Whether one is an urban planner, a cabinetmaker, or a sculptor, he or she sets out to solve a problem, to address a need. This translation from concept to form involves a set of sophisticated skills: the selection of materials; decisions about their fittingness; hand-eye coordination; mastery of tools; and judgments concerning the completion of the task. These kinds of actions and decisions forge a relationship between a maker and his or her material forms.

Naturally, Bruce Herman's paintings bear no burden to redesign a neighborhood or to store one's possessions. They accomplish a different kind of work. But what, then, is the nature of his task? On several occasions Bruce has reminded me that the farmer, the painter, the smithy, and the poet are, together, *Homo faber*—persons who make and create. Although this understanding of human vocation is as ancient as the opening chapters of Genesis, it has fast become a radical notion. Here is why. Increasingly in the developed West our concept of the "self" is derived from personal patterns of consumption. It is widely known that we consume a disproportionate share of what the non-Western world produces and that this is surely unjust. But in this economic order there is more at stake: the loss of our true self as *Homo faber*. That is, when our primary sense of being in the world centers on consumption, then our role as makers and creators—our meaning-filled participation with and in Creation—can only be diminished.

If works of art hope to endure—even for a season—they must serve a larger discourse and move beyond mere entertainment for consumers. Bruce's paintings and drawings are meditations on big ideas and meaty texts like Holy Scripture, the writings of Orthodox thinker Pavel Florensky, and T. S. Eliot's *Four Quartets* (1943), to mention a few. (Regarding his fascination with Eliot, for a good while it was not uncommon for Bruce to carry about a dog-eared copy of the poet's work in the hip pocket of his jeans—until, that is, he memorized the passages most dear to him.) But Bruce's work is not summoned solely from the world of ideas. Rather, it bears witness to his visceral connection to the topography of the land and sea of Gloucester, Massachusetts, where he lives with his wife, Meg; repeated stays in Orvieto, Italy, and its surrounds; fascination with the history of painting from Giotto to the present; and not least, the Church, its word, sacrament, and community. All appear in his work. In other words, Bruce Herman's work ventures forth, as it must, from his life.

In the opening paragraphs of this introduction, I explained how it was that Bruce's postcard became "icon-like" to me. To the secular, consumer-oriented mind the term *icon* is now mostly dissociated from the sacred. The word now refers, instead, to familiar and arresting images designed to gain and then hold our fleeting attention amid the dizzying visual spectacle of contemporary life. Modern icons are perceived to be nothing more than pixelated symbols, points of colored light on our LED or LCD screens.

By contrast, the holy subjects and surfaces of real icons—in the older pre-modern and sacred sense of the term—figure importantly in Bruce's work. Over several decades biblical narratives such as the Creation, Annunciation, Suffering Servant, and Crucified Christ have cycled in and out of his work. Aiding these themes has been the shimmer of silver and gold leaf on and beneath the surface of the work. He pairs these precious materials with the glimmering light of pigment—highlight and shade that fall across human form and architectonic space. In the end, these subjects and surfaces counter the prevailing notion that art and religion must, at all cost, be consigned to separate spheres. Bruce Herman's oeuvre quickens the older—dare we say it?—primordial sense that the material can bear witness to the spiritual; that art can serve as a sign of God's holy presence and, as such, aid us in prayer and in life.

As I write this introduction, John Berger's book *The Shape of a Pocket* (2001) has become a companion of sorts. And as his epigraph at the beginning of this introduction suggests, the artist's task is to welcome that which has thus far been absent. Again, this assumes that our waiting and wanting in this meaning-filled material world exists according to some

purpose—has a *telos*. In partnership with other disciplines, art's task is to help us recover what, thus far, has been absent. At the end of the day and perhaps nearer the end of our lives, we recognize that our real quest is to know the Other, a particular Other. We hope for the real presence of God come over us, to be overwhelmed by the Spirit of Christ, as was Moses when he stood before a bush that was not consumed.

It is my good fortune to own one of Bruce Herman's more recent works, titled *Mapping Midnight* (see fig. 2). An artist myself, I am ever eager to understand how others build their paintings. I study their moves. Was the paint applied by brush or palette knife, sanded or scraped, glazed or varnished? Paint being paint, it leaves a record of everything from the preparation of the surface substrate and its ground to the deliberate strokes and happy accidents that are caused by the artist's hand. The horizontal and diagonal lines of *Mapping Midnight*, which measures 23 × 24 inches, remind me of the structural space that I like so well in the work of Richard Diebenkorn (1922–1993). The painting's more lyrical passages recall, for me, the brushwork of Willem de Kooning (1904–1997); and its overall painterly character bears evidence of Bruce's graduate school mentor, Philip Guston (1913–1980). Like the multivalent surfaces, colors, and forms of so many Herman paintings, this painting is given to a dark kind of beauty and unabashedly so.

At the same time, I know this painter well enough to be certain that he would take no satisfaction in a facile beauty that failed to lead his viewers beneath the surface of things, to larger structures, ideas, and ways of being. In his short essay on Constantin Brancusi (1876–1957), John Berger suggests that the sculptor "instilled an ache into stone: the ache of desire for a lost

unity." He locates this longing after the Fall, outside of Eden, and regards it as evidence of our desire to recover what has been lost. The beauty that I find in *Mapping Midnight* is like this. It is an aching beauty. For Christians, at least, here is the truly good news: at the end of chronological time, we will shed the "dark glass" or "dim mirror" (see 1 Cor. 13:12) that now clouds our vision and gain striking clarity. The "things of earth" will not "grow strangely dim" but rather more vivid—more vivid than we dared to imagine.

The pages that follow invite us to consider the paintings of Bruce Herman paired with the musings of Bruce's interlocutor and friend Walter Hansen. In other words, the images and essays this book contains are about more than one artist's work, splendid though it is. Indeed, these pages showcase the friendship of Bruce Herman and Walter Hansen, their spiritual and intellectual fidelity to each other as brothers in Christ. One is a painter and highly esteemed college professor and the other,

a biblical scholar and art collector. Both are travelers of this great world who long, even more, for the new world that is to come. *Through Your Eyes* embodies Bruce and Walter's mutual desire to get to the bottom of things. Herman's paintings are, for them, sites that enable a kind of spiritual and aesthetic sleuthing.

The enquiry that follows seeks to locate those places where great art and literature intersect with human geography and experience. Consequently, in making our way through this book, we join an artist and a biblical scholar in their desire to fit the pieces of the existential puzzle together—to make progress in the shared task of restoring all things to their proper place.

Cameron Anderson

Madison, Wisconsin
March 18, 2013

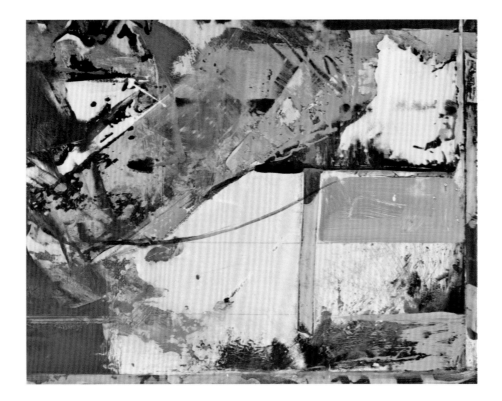

fig. 4. detail: *Mapping Midnight* © 2007 Bruce Herman; oil on board, 23" × 23"; collection of Cameron and C.K. Anderson

Invitation to *Through Your Eyes*—a Conversation in Art

"The artist does not exhaust the significance of his or her labor, but creates an object, a schema of perceptible data, that will have about it the same excess as the phenomena that stimulated the production in the first place. Art moves from and into a depth in the perceptible world that is contained neither in routine perception nor in the artist's conscious or unconscious purposes."
—Rowan Williams, *Grace and Necessity* (pp. 149–50)

In what follows the authors invite the reader into their ongoing conversation about Bruce Herman's art, but also about art and faith more generally:

G. Walter Hansen: "What do you see?" This was your challenge to me when I first stood before one of your paintings, *Rome: A Vision* (see fig. 7), and asked you for your artist's interpretation of the image. Now, after years of conversation with you about art, I know that you will usually respond to my question with a question. I am still amazed that you want to see your art through my eyes. Your invitation to look, discern, and interpret on my own began what has become an ongoing great conversation—not only about your art work, but about contemporary art in general and its relevance to our shared Christian faith.

Bruce Herman: Right. But your immediate willingness to venture into the potentially embarrassing business of interpretation (especially with the artist present) equally challenged me, and in fact caught me off-guard for a moment—particularly when you came up with a different interpretation from my own. A completely valid one, I might add, and one that stretched me.

WH: How can you honestly say that my "take" on your painting was equally valid or true to your own? Isn't the meaning of your painting tied to what you had in mind when you painted it?

BH: Well, let's put it this way, I wasn't going to reject the view of a potential buyer! But kidding aside, I was instantly taken with your interpretation. It went significantly beyond my own limited view.

WH: If my interpretation goes significantly beyond yours, how can you accept it as a legitimate interpretation?

BH: Because I "discovered" the image in the process of making the painting (this happens often), I don't have a sense of ownership of the image. It's almost as though it arrived on its own as I was working (a bit like taking dictation). The central figure, bent over and sorting through the dirt or dust, seemed to me to be someone writing on the ground—perhaps like Jesus in the story of the woman caught in adultery. I didn't try to frontload the image with a "message" so much as place it out there for the responsive viewer to interact with. My own feeling was more allusive and ambiguous . . . which of course leaves room for your own response to the painting.

fig. 5. Bruce Herman and Walter Hansen in Herman's studio

WH: Yes. But I see something different from what you apparently intended—so much agony in the figure, heaving with sobs, in grief over the rubble of the City, destroyed and sinking into oblivion. So what I see is really different from the image you discovered in the process of painting it.

BH: I see your point—but what I intended was to make a painting that is "alive"—that is, inviting personal response, not dictating a narrow meaning. Your interpretation is really a legitimate personal response that actually harmonizes with my own in the following sense—that a Christ figure, writing in the dust on the occasion of someone being broken or accused, would indeed evoke this sadness you see. And I now see the same thing in the image that you do: Christ's compassion aroused for the City in general in the same way he extended forgiveness to the adulterous woman. So your receptivity has simply expanded the possible horizon of interpretation. This seems completely natural to me, and in the process I learn more about the very image I've painted.

WH: Your generous invitation to ask me what I see in your art really impressed me. I was overwhelmed by the piece. My earliest essay in our book (chapter 1, "Rome: A Vision") recalls that first encounter and my thoughts following that initial look. My hope for our book is that it will extend your invitation to our reader: "Come and see" or "What do you see?" That's why I suggested our title, *Through Your Eyes.* I hope that many more will see your work and be changed by it.

BH: Honestly, this is the most encouraging thing that could ever happen to an artist—to have a committed and sensitive interpreter of his work turn and open the whole thing up to others . . . to invite others into our conversation, to invite others to see the work through their own perspective. Though I have a deep commitment to my own understanding of what I'm doing in these paintings—and, indeed, I hope others will receive what I am putting out there—I really do believe that the responsive viewer completes the art. It's a bit like bringing a book to life by reading it aloud. Without the sense of community that comes into our conversation about the work, it just lies there dormant. The artwork is out there on its own and is "asleep" until you, the responsive beholder, allow it to come alive in your eyes.

WH: That is the aim of my comments in this book—to introduce others to your paintings, so that they can enjoy them and come to see their complex beauty and "excess of meaning" (to use Rowan Williams's phrase from *Grace and Necessity*).

BH: Which is why I am so delighted that we get to do this book together—bringing others into our conversation and beginning to expand that excess of meaning. Thanks for introducing me to Rowan Williams's thoughts on art. He's captured my feeling exactly—that a work of art has a life of its own, even beyond its creator's intentions—and the artist stands before his works precisely as everyone else does, much as a parent views an adult child (free of "ownership").

WH: Our dialogue about your art is not always easy. Although I feel deeply enriched by your art, sometimes I find your paintings troubling and disturbing. We'll use this book to show how an artist and one of his interpreters engage in conversation from different starting points and different interpretive assumptions.

G. Walter Hansen and Bruce Herman

Bruce Herman G. Walter Hansen

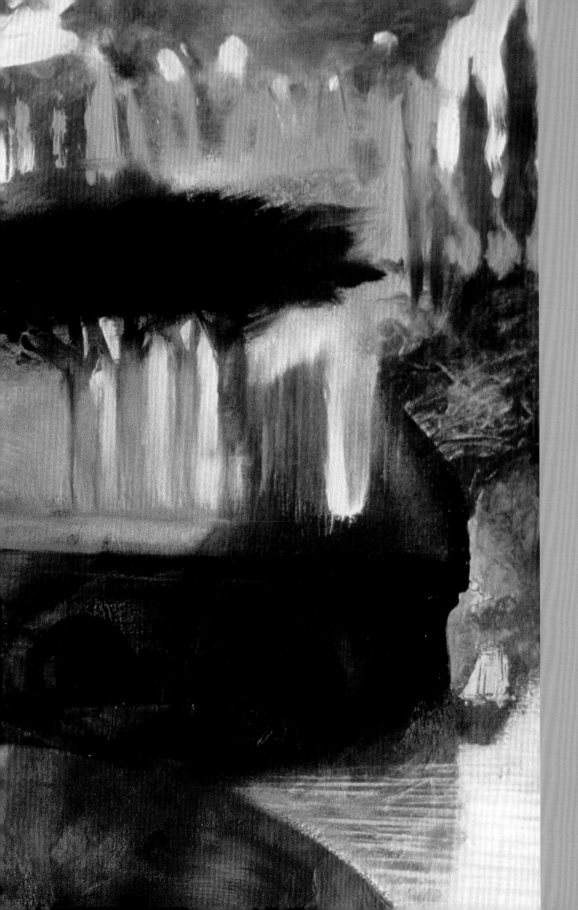

Rome: A Vision

fig. 6. detail: *Rome: A Vision* © 1999 Bruce Herman; oil on canvas,
60" × 48"; collection of Walter and Darlene Hansen

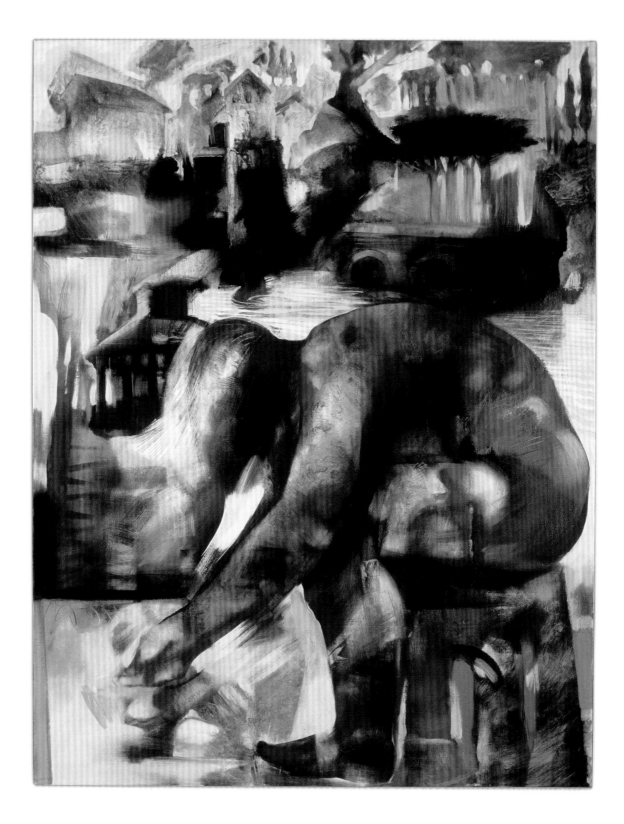

Chapter 1

Rome: A Vision

S.W. Hansen (signature)

Rome: A Vision means much more to me now, seven years after I first saw it in June 2005.

When I first stood in the presence of *Rome: A Vision* (see fig. 7) in Orvieto, Italy, at the exhibition in the Palazzo dei Sette, Bruce asked me, "What do you see?" I saw a man sitting in the foreground, his chest pressed against his knees, his head bent down to the ground. It seemed to me that his whole body was heaving with heartrending sobs. In the background I saw a city that looked like ancient Rome, but the pillars and arches were broken and half-submerged in water. What I saw made me think of Jesus weeping over the city, not only over Jerusalem or Rome, but the City of humankind, sinking into self-destruction and despair.

As a result of my time in Rome, examining the rubble and ancient artifacts in the Roman Forum, the week before visiting Bruce in Orvieto, I was perfectly set up to be rocked by this painting. And I was rocked—knocked down. For a while I could not answer Bruce's question. I felt like the man in the painting. His position, bent over with his chest pressed against his knees, is my position on those occasions when I am completely overcome by grief. Finally, after struggling to regain my composure, I simply pointed to the man and said, "That is Jesus weeping for all cities, weeping for all of us broken people."

Then I saw something more: The arms of this man are reaching down into the dust. I saw dynamic, purposeful movement in his arms and hands. It seemed to me that the man was reaching down into the dust to remake, to rebuild, and to create a new city, a new humanity, out of the dust. The man is not only weeping over fallen humanity, he is also reaching out to shape a new creation out of dust.

> I was perfectly set up to be rocked by this painting. And I was rocked— knocked down.

fig. 7. *Rome: A Vision* © 1999 Bruce Herman; oil on canvas, 60" × 48"; collection of Walter and Darlene Hansen

I immediately bought the painting. In the years that followed, as it hung on the wall across from my desk at home in Santa Barbara, California, I often lifted my eyes and moved into the space it created. As I contemplated every line, every variation of color, the dynamic form of the man in the foreground, and the sinking shadows in the background, the painting spoke to me on many levels and in many contexts.

This image of Christ became a constant source of encouragement as I prepared to teach classes on the four Gospels at Fuller Theological Seminary. After teaching the same course year after year, I was always looking for fresh insights and personal renewal. Meditating on the texts, reading volumes of commentaries, reworking outlines, and polishing presentations were all essential aspects of my work. Yet beyond all that I found a quiet center in the presence of Jesus by contemplating this image of him weeping over the ruins of the City and reaching down to build his new community.

The painting also became a focus of conversations with family and friends who sat with me in my small study in our home. I found that I could explain my expanding international travel to those closest to me by pointing to *Rome: A Vision*. Walking in the slums of megacities in Africa and Asia, visiting hospitals, participating in microfinance projects, and teaching at seminaries and pastors' conferences are all primarily motivated by my desire to follow Jesus in his ministry through the church to the poor in the urban centers of our world.

When we moved to Chicago in 2011, I hung the painting in my office, a much more public place than my home study. For the past two years, partners in diverse global projects and in ministries here in Chicago have looked at *Rome: A Vision*. Following the example of my mentor, I ask them: "What do you see?" Bruce taught me that the meaning of his painting is not limited to his motives and purposes for producing it. Just as he wanted to see his painting through my eyes, I now want to see the painting through the eyes of others. I am finding that the "excess of meaning" in this painting keeps expanding as I listen to what others see in it.

Brian Jenkins leads a ministry to at-risk youth in Chicago that trains teachers to lead a course in after-school programs called "StartingUp Now: 24 Steps to Launch Your Own Business." In areas of our city where unemployment is above 50 percent and crime statistics increase every year, he seeks the welfare of the city by guiding young people to be entrepreneurs. When Brian visits me from his office down the hall at the Daystar Center in Chicago's South Loop, he always takes time to gaze at the painting.

"That's what I'm trying to do," he says. "I hope to lead my people out of self-destruction into personal growth and business success." Brian says he tells many people about this painting because it motivates him and others in their work in the city. By seeing the painting through his eyes, I now view it as an image of what is happening here in my hometown, Chicago. The Man of Sorrows in the foreground is reaching down to build the City of God here.

This painting hanging in my office is an icon in the center of my life. I no longer read or interpret the painting so much as I pray in its presence and experience the mystery of the Real Presence. I do not mean that the painting itself is the Real Presence; rather, it leads me into the real presence of my Lord as I see the compassion of the Suffering Servant: "Surely he has borne our grief and carried our sorrows" (Isa. 53:4).

And I hear his promise: "On this rock I will build my church; and the gates of hell will not prevail against it" (Matt. 16:18).

fig. 8. Walter Hansen and his friend Brian Jenkins at the Daystar Center in Chicago's South Loop

Rome: A Vision

B. Herman

Bruce offers a little background to *Rome: A Vision* . . .

On September 12, 1997, lightning struck our home and caused a catastrophic fire that consumed most of our belongings and nearly all of my remaining artwork from the 1970s and '80s (including all of the unsold *Dream of Wet Pavements* series and all of my undergraduate and graduate work). It took the better part of 1998 to rebuild and restore some semblance of order to our lives. However, by God's grace and with the help of our friends, neighbors, and our church, we weathered it well. No one was injured. My dog, Shadow, and I escaped the flames before the conflagration reached the upper levels of the house.

The summer just prior to the fire I had begun a series of paintings and drawings that addressed the theme of Isaiah 61:3–4:

> . . . to bestow on them a crown of beauty instead of ashes, the oil of joy instead of mourning, and a garment of praise instead of a spirit of despair. . . . They will rebuild the ancient ruins and restore the places long devastated; they will renew the ruined cities that have been devastated for generations.

I had recently returned from a visit to Italy, where I had seen preparations all over the country by the Vatican for the second millennium Year of Jubilee, the momentous Y2K. Many of the great monuments and cathedrals were covered with scaffolding. I was struck by the surprising beauty of the scaffolding and by its ambiguity: were these great edifices being demolished or restored? It piqued my sense of the mystery of the Isaiah passage—rebuilding the devastated cities and ancient ruins. A few months later, when our own home needed rebuilding after the fire, I felt deeply prompted to give myself to my painting series about building in the ruins.

Out of the ashes of our house and studio fire, I found beauty by making paintings that dealt with the "already and not yet" aspect of God's coming kingdom—the simultaneous ruination and hopeful redemption that this broken and bruised world can sometimes evoke.

Rome: A Vision is part of the *Building in Ruins* series (see a more full discussion in chapter 6), with all of the obvious and perhaps not-so-straightforward elements you might imagine. One very clear purpose behind the series was an attempt to evoke the ambiguity of the already/not yet reality of the new heavens

fig. 9. detail: *Rome: A Vision* © 1999 Bruce Herman; oil on canvas, 60" × 48"; collection of Walter and Darlene Hansen

and new earth. In the midst of ruined buildings and watery destruction there is a colorful, hopeful action taking place: the large figure in the foreground is not simply crippled with grief or misery but is working in the dirt, the sand, the stuff of the painting itself. After all, paint is nothing but colored dirt held together by oil or some other binder. And one of the central aims I had then (as now) was to show that paint itself, color and shape and texture—the very surface of the painting—contains a large measure of the meaning of my art.

I am not simply trying to illustrate a "message"—a verbal idea or meaning. I am trying to grapple with the ambiguities and paradoxes of our human situation. We are painfully aware of the faults and failures of humankind, but also hopeful that through technology and science and medicine we will build a better future world for our children than we ourselves have known. But I am also asking difficult questions that acknowledge the seeming fruitlessness of all utopias. Judging from most of human history, we cannot build a fair and flourishing civilization that will last. All of our kingdoms have fallen, and recent developments in the global economy and global political unrest have driven this home yet again.

Rome: A Vision utilizes a trope that should give a clue to at least one layer of meaning. The figure is bent over, weighed down by care, yet reaching into the dirt in either a gesture of distracted grief or childlike play. In fact this figure is, in one sense, a quotation of William Blake's etching of Isaac Newton (fig. 11).

This knowledge is not necessary in order to encounter the image or derive other layers of meaning from it, but my own study of Blake's prophetic poems and paintings has deeply affected me over the years—particularly as I have contemplated the fate of the human city, symbol of our attempts to provide a place of security, power, and safety. Yet our cities are often also places of unprecedented pain, poverty, and misery. Blake's book *America: A Prophecy* is a meditation on the hopes of the New World: refreshment from the stale religion and politics-as-usual of eighteenth-century England and the European continent. He foresaw in the United States a radical equality of the sexes, opportunity to rise above class and caste, and a passionate embrace of the arts—without the tyranny of settled power and Blake's chosen enemy, rationalism.

Blake's *Newton* shows a problematic, ambiguous figure. He is both an ideal man and, for Blake, a symbol of futility because the brilliant physicist misses the essential beauty and mystery of the world around him—lost as he is in his own formulas and geometric designs. Blake used the compass in a number of his paintings and prints as a symbol of the failure of rationalism to yield a hospitable world. His mythic character Urizen is often shown holding a compass—as though measuring and

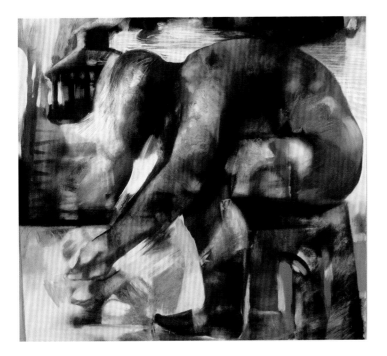

fig. 10. detail: *Rome: A Vision* © 1999 Bruce Herman; oil on canvas, 60" × 48"; collection of Walter and Darlene Hansen

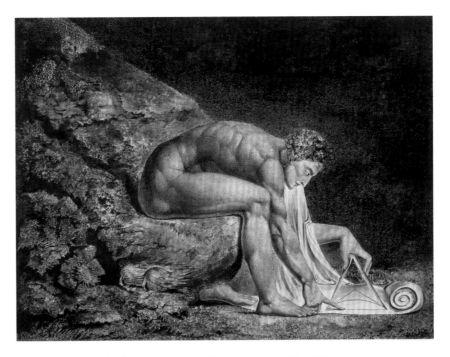

fig. 11. *Newton*, 1795/circa1805, William Blake (1757–1827) ©Tate, London 2013

delimiting were all he is capable of doing. For Blake, and for many of us living two centuries later, technology is a fraught thing. It has largely borne the very fruit that Blake inveighed against: overcrowded cities, factories that pollute, mass-produced substandard goods, and profoundly inhuman military machines. My own figure is, as Walter intuited, more of a Christ figure weeping over the results of the human city with all its self-idolatry and control. Unlike Blake's figure of *Newton*, my Christ figure bends to the earth not to measure but to embrace and touch the raw material of a new city.

I do not see the human city or technology as bereft of hope and creative power. *Rome: A Vision* is, I believe, a vision of redemptive grace, not merely an indictment of human folly and hubris. The title of the series, *Building in Ruins*, is deliberately ambiguous—because some of our history is, in fact, a building in ruins. But we are also called to continue to risk and build for a better future, called to build amid the ruination of our times.

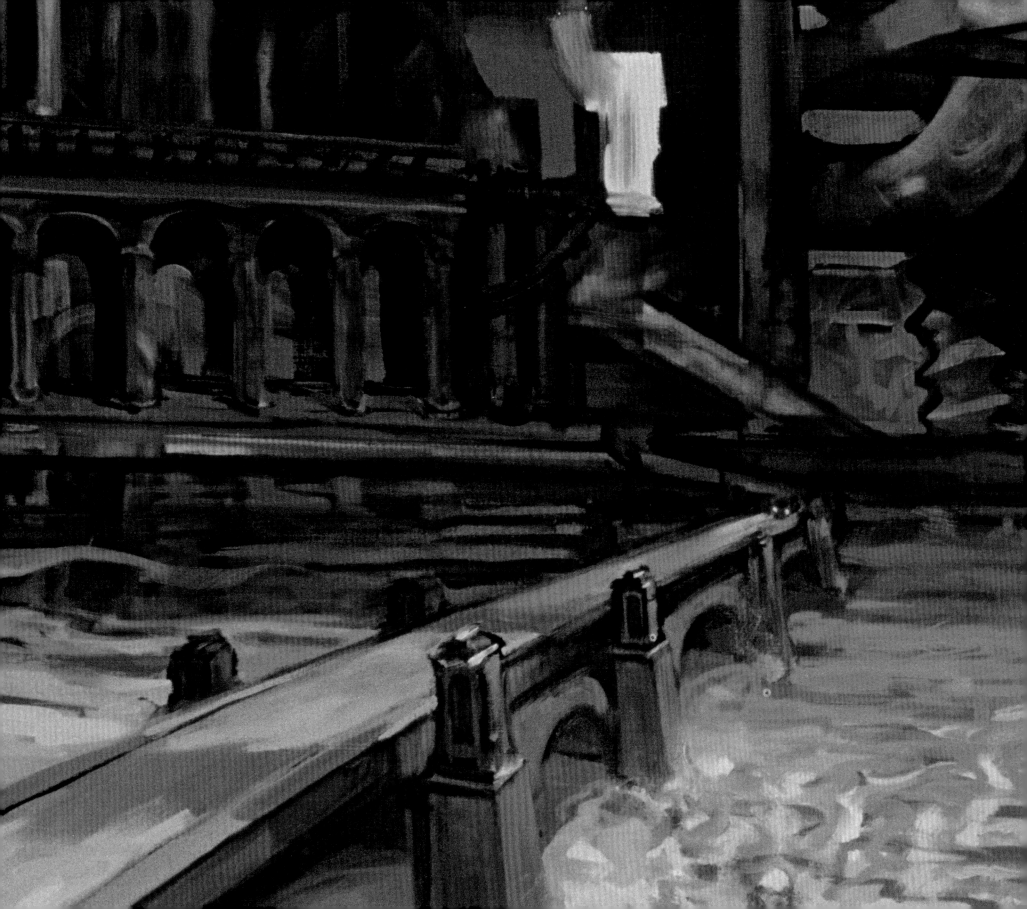

Dream of Wet Pavements

fig. 12. detail: *Inbound* (from the series *Dream of Wet Pavements*) © 1989
Bruce Herman; oil on canvas, 55" × 55"; courtesy of the artist

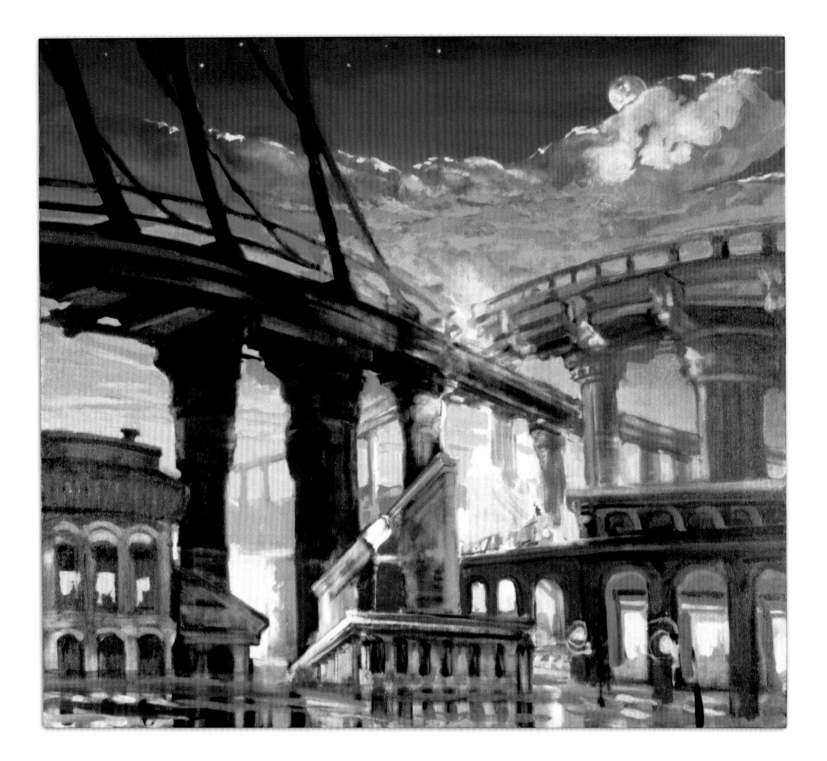

Chapter 3

Dream of Wet Pavements

[signature]

Bruce Herman's cityscapes capture my own experience of cities: the juxtaposition of traditional and modern architecture, the contrast between dark shadows and luminous colors, the mixture of rubble and scaffolding, the interweaving of humanity and machinery.

Only the human genius and energy concentrated in the city could have produced these skyscraping structures, these nearly infinitely complex infrastructures. Cities exert a strong magnetic pull on us. In *Dream of Wet Pavements: Moonrise* (fig. 13) and *Dream of Wet Pavements II* (fig. 18), Bruce gives us a sense of the history of this collective mind by layering classical pillars, soaring arches, the straight lines of new towers, and the sweeping arcs of modern highways.

Yet I see human forms caught and crushed in *The Man & the Machine* (fig. 17), *Man & Machine V* (fig. 14), and *All Attempts to Restore Order* (fig. 16). Enmeshed in pistons, screws, levers, and wheels, arms and legs reach in vain for freedom. There's no exit, no escape from the city's powerful forces. Machines crucify the human form in *The Man & the Machine* and *Crucifixion* (fig. 15). Technology tyrannizes the human spirit. I see cities imprisoning, dehumanizing, and degrading people. I see the millions of immigrants who have come to cities looking for work and love—many of them rejected, reduced to abject poverty, herded like animals into ghettos, demeaned by cruel bosses, and brutalized by violence.

In short, these paintings do not sentimentalize cities by removing any hint of their dark side. These are not glistening-white, warmly glowing "shining cities on hills." In the waterfalls of Bruce Herman's cityscapes, I see rivers of people from every tribe and tongue, "huddled masses yearning to breathe free."

Only the human genius and energy concentrated in the city could have produced these skyscraping structures, these nearly infinitely complex infrastructures.

fig. 13. *Dream of Wet Pavements: Moonrise* © 1988 Bruce Herman; oil on canvas, 50" × 60"; collection of Nola Falcone

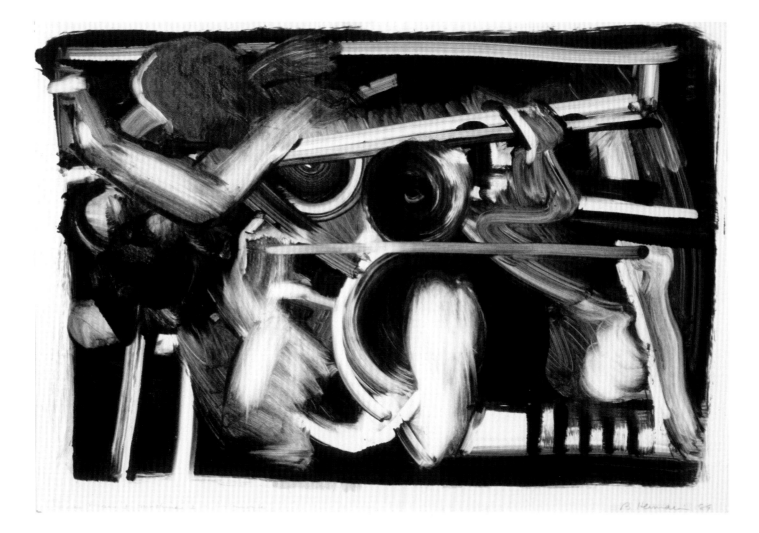

fig. 14. *Man & Machine* © 1988 Bruce Herman; monotype; 22" × 30"; damaged in studio fire of 1997; collection of the artist

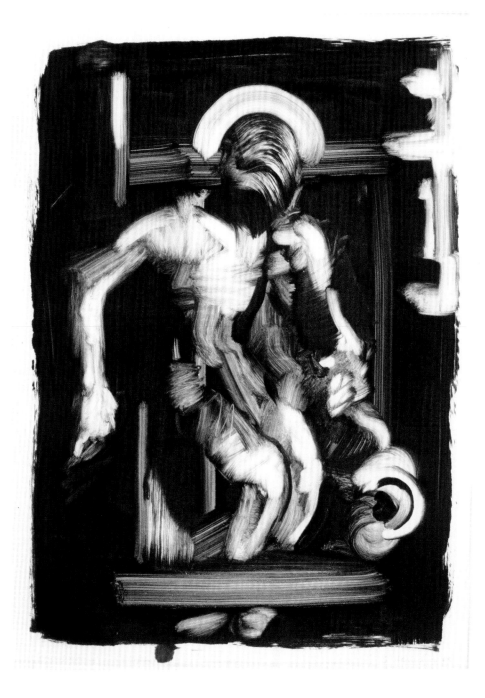

fig. 15. *Crucifixion* © 1988 Bruce Herman; monotype; 22" × 30"; collection of Robert and Patricia Hanlon

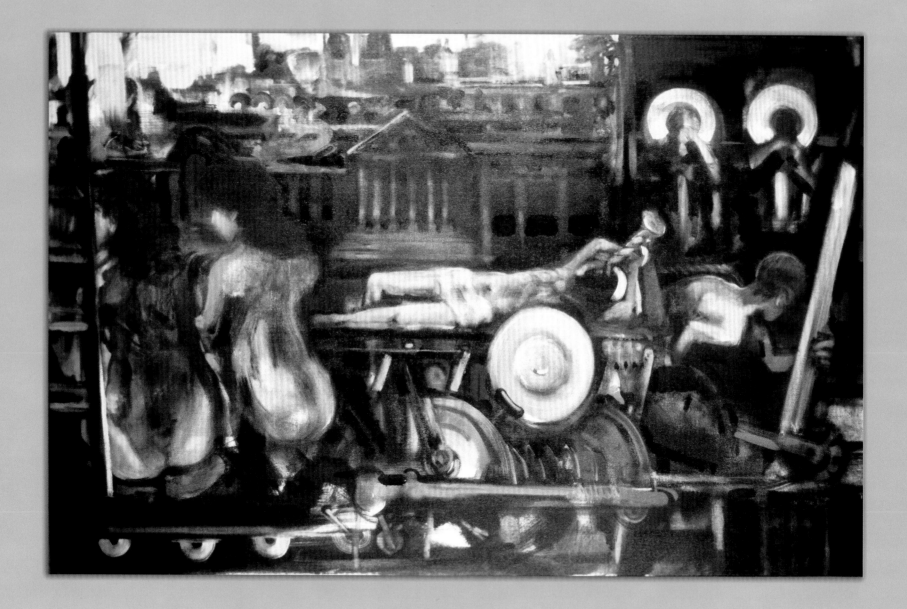

fig. 16. *All Attempts to Restore Order* © 1988 Bruce Herman; oil on canvas, 40" × 65" ; over-painted as *The Man and the Machine* 1989

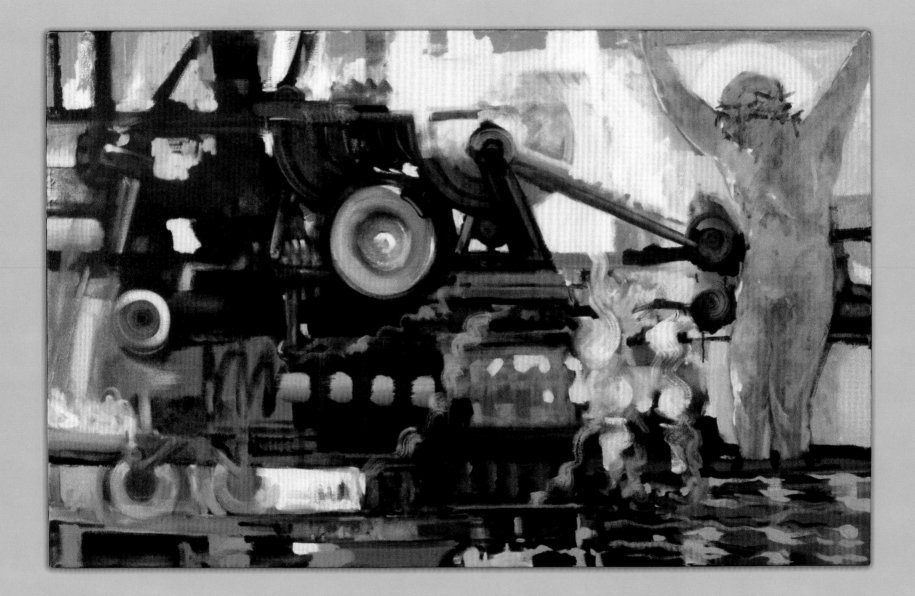

fig. 17. *The Man & The Machine* © 1989 Bruce Herman; oil on canvas, 40" × 65" destroyed in studio fire of 1997

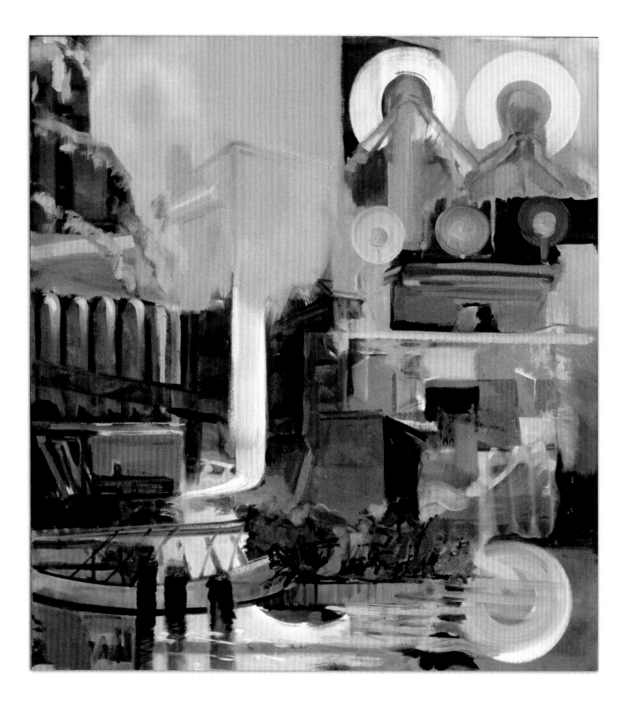

fig. 18. *Dream of Wet Pavements II* © 1988 Bruce Herman; oil on canvas, 65" × 50"; destroyed in studio fire, 1997

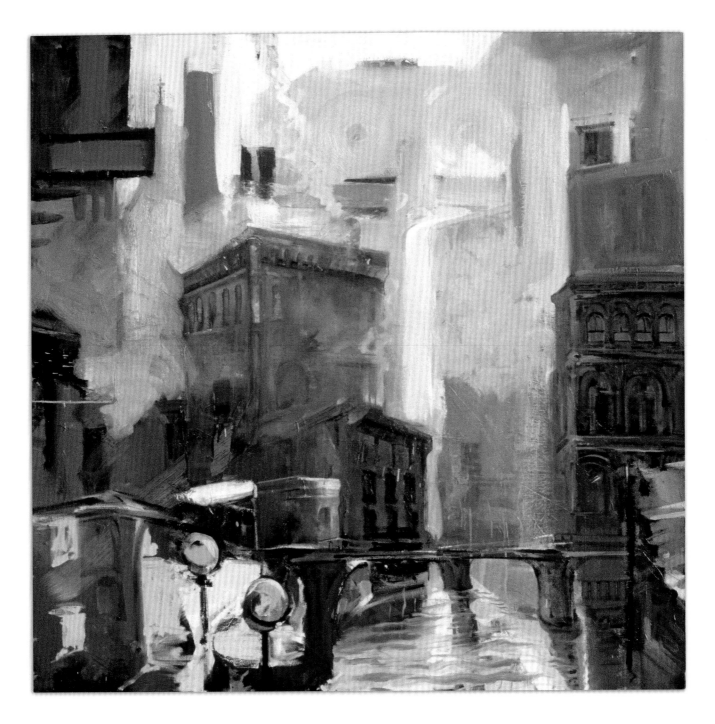

fig. 19. *Dream of Wet Pavements* © 1988 Bruce Herman; oil on canvas, 72" × 60"; collection of Thomas and Susan Brooks

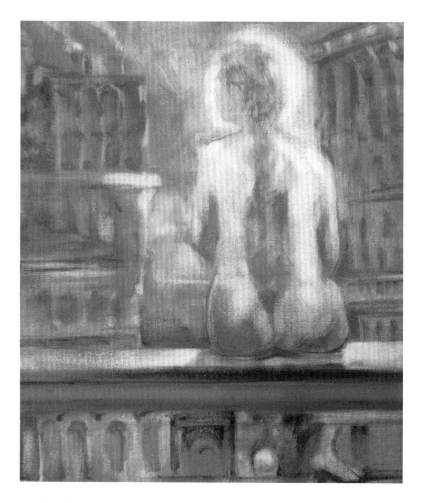

fig. 20. *Witness Wall* © 1989 Bruce Herman; oil on canvas, 16" × 14"; collection of Robert and Patty Hanlon

I see the city's diversity resulting in fear, tension, and conflict. I see gangs maintaining exclusive identities and fighting to dominate their space in the city. I see the alienation between ethnic groups threatening the peace and prosperity of the city.

I see doors shut and walls built to keep out the "other," the different person. I see the resulting resentment, bitterness, and hatred.

And yet these cityscapes still fill me with love and hope for the city's future. When I see the radiant, glowing colors illuminating the streets in these paintings, I remember brilliant witnesses to beauty, truth, and goodness in churches and galleries, in townhouses and offices, and in hospitals and factories of the cities. I recall ingenious people using the forces of technology to nurture communities for spiritual growth, to craft frameworks for human freedom.

When I see waterfalls in *Dream of Wet Pavements I* and *II* (fig. 19 and fig. 18), I also see rivers of renewal. Walking through slums of megacities, I meet streams of people once destitute, but now with steady incomes from their small businesses; people once isolated in their poverty, but now meeting in small groups to plan, study, pray, and sing; people once embittered and fearful, but now finding dignity and confidence in their work and their dance. Small streams become waterfalls, transforming families, homes, and whole regions.

I see waterfalls of music, visual art, drama, and dance. As I write these words, a waterfall flows toward me in Manhattan: *Picasso* at the Met; *The Body Beautiful: The Human Form in Modern Art from Cézanne to Klein* at MOMA; *Mostly Mozart* at Lincoln Center; *Red* on Broadway; *Emily Dickenson's Garden: The Poetry of Flowers* in the New York Botanical Garden; and *La Bohème* at the Metropolitan Opera.

Diversity in the city creates opportunities for cultural enrichment and spiritual growth as people with different backgrounds listen, trust, and learn from each other. A faith club with Muslim, Christian, and Jewish participants develops rapport, gains understanding, and finds reconciliation, building strong relationships. When I see the luminous waterfalls in these cityscapes, I have hope that my city, Chicago, will have the heart-room to tear down walls, open doors, and embrace others, no matter how different they are from us.

I see a nude female figure in *Witness Wall* (fig. 20). Her nudity makes me think of the television series *Sex in the City* and burlesque shows—after all, cities sell sex. Bruce redirects my wayward mind by showing me that the woman represents an angelic being—benevolent, not malignant—embodying the spirit of the city. This provocative image—a visual representation of the community spirit, the collective mind of the city—sits on the wall, seeking the welfare of the city. She pursues social harmony and human flourishing.

In Bruce's painting *Inbound* (fig. 23), the highway breaks through the front of the picture plane, opening a way into the city. Uncharacteristically, this highway is empty. Usually, traffic jams highways into cities because cities are marketplaces for every conceivable product; they thrive and prosper on open, free trade. Trade drives the constant invention of newer and better products. Inventions used for life-giving purposes build up the city for human flourishing; inventions used for destructive purposes destroy the city.

What will be the future of cities? Decay or renewal? Tyranny or freedom? Destructive catastrophe or innovative creativity? Now that more than half the people of the world live in cities, understanding the meaning of human life depends more than ever on understanding the meaning of the city. Bruce Herman's cityscapes guide us to probe and discover this meaning.

Bruce's *Against Chaos* (fig. 21) provides hope for the future of the city. Even though the foreground is strewn with shattered structures and may suggest deconstruction, the man is stretching his arm into open, bright blue space, designing and directing the construction of a new city, one that will enhance human capacity and creativity. Like the figure of Christ in *Rome: A Vision* (fig. 7), this man reaches into the chaos of pervasive ruins in order to create afresh—to see new possibilities instead of the hopelessness of destruction. This new city will promote hope and human well-being not only by meeting basic needs for shelter, food, and education, but also by providing opportunities for meaningful work, social networks, and the enjoyment of beauty in the city's concert halls, art galleries, restaurants, and lush gardens.

Bruce's paintings point toward this very hope while at the same time honestly acknowledging the surrounding ruination. The human figure in the middle of *Against Chaos* represents for me my own place in the city—even specifically my hometown, Chicago. Drawing from the rich traditions of the past and with the creative tools of the present, I seek the welfare of Chicago. I seek to help establish justice, to show mercy, and to walk humbly with my God and neighbor in my city (Micah 6:8).

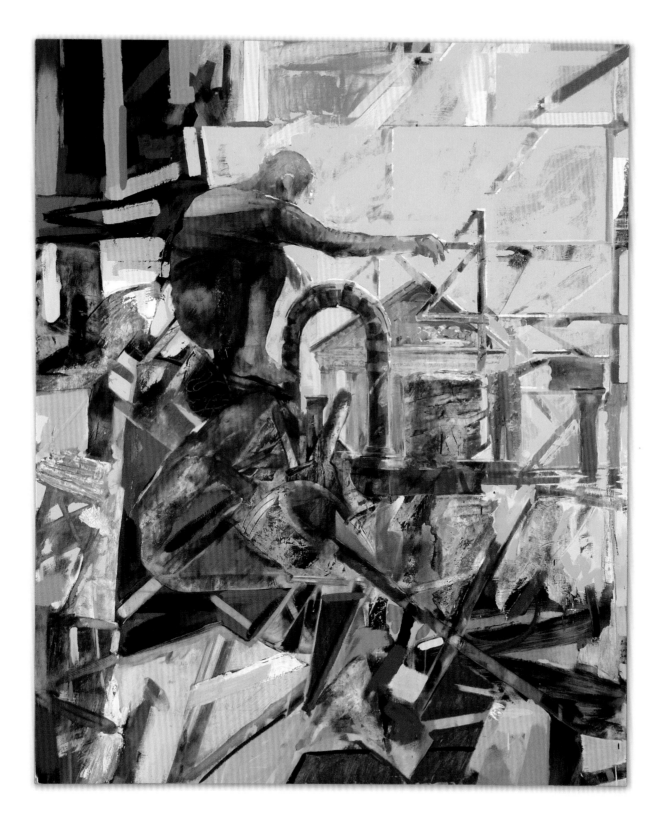

Chapter 4

Cityscapes

[signature: B. Herman]

When I began this series of imaginary cityscapes *(Dream of Wet Pavements)*, I had recently moved from Dorchester (inner-city Boston) back to Boston's North Shore, to Cape Ann (Gloucester), where I had met and married my wife, Meg, in the early 1970s. At a comfortable distance from the urban din, now living in a semi-rural northern coastal area, I began to digest or attempt to reconcile some of the contradictions of city life: in the urban setting we live in close proximity but often experience isolation and intense privacy in comparison with rural or suburban life (where it is often easier to know and be known by others—perhaps ironically, when acres of space surround each of our dwellings). Other aspects of city life percolated down as I thought and felt through our eight years in Boston: the competition; the sense of high-energy and simultaneous expenditure of effort to accomplish the simplest tasks; the feeling of significance deriving from the cultural pulse of the times, but also the anomie and potential for despair.

I thoroughly enjoyed living in Boston and pursuing the cultural work that was set before me. Yet I had the persistent sense that the spirit of the city was not always one of community and caring—rather, it seemed often to be about name, fame, power, status, and the like. Of course, this could be a caricature of urban life for anyone who lives and thrives in that setting. But for me and for my family, life in the city had grown stress-filled and even toxic at times.

Around the time of our move from Boston, a slew of dystopian urban post-apocalyptic movies had come out—*Koyaanisqatsi, Blade Runner, Brazil,* the *Mad Max* series—and simultaneously I had discovered Jacques Ellul's books on technology and the city: *The Technological Society* and *The Meaning of the City.* Having grown up in the 1960s in the shadow of the atom bomb, along with my generation I was predisposed to think human technology was potentially "bent," creating a

> At a comfortable distance from the urban din, now living in a semi-rural northern coastal area, I began to digest or attempt to reconcile some of the contradictions of city life.

fig. 21. *Against Chaos* (from the series *Building in Ruins*) © 1999 Bruce Herman; oil on wood, 72" × 48"
collection of Taylor University

More than 70 percent of the earth's surface is covered by water; thus water is the major symbol of hope and of new possibilities, not just of deluge and destruction.

world inhospitable for human flourishing. The city seemed to fit the bill.

We had already moved away from Boston, yet I found myself drawn to painting urban images. The city images that spontaneously came to me in my painting process were all dreamlike and mostly devoid of explicit human presence—like a ghost town. All of the images in the *Dream of Wet Pavements* sequence contain water imagery but are ambiguous as to whether the water is rising or receding. The title *Wet Pavements* is obviously an understatement when you view the half-submerged buildings, bridges, and roads. Though I was reading Ellul and watching dystopian films about technology and urban blight, I was also reading in Scripture of the stunning and hope-filled truth that at the end of human history we don't return to Eden but become citizens of a city—"the city with foundations, whose architect and builder is God" (Heb. 11:10).

I wanted to paint images that captured this paradox. Ellul points out, in *The Meaning of the City*, that it was Cain (a murderer) who founded the very first city, and that this act revealed that Cain did not trust God to provide for him. Hence the first city was the result of self-provision, a silo-city, a place of hoarding, of self-defense, of power and mistrust. Yet Scripture indicates that God's ultimate destination for us is just that, a city—presumably something akin to Augustine's *The City of God* and certainly

symbolized in the prophecies of John on the island of Patmos, as recorded in Revelation. As an artist I am always attempting to show what cannot be fully articulated in speech—namely, the contradictions and paradoxes that abound in human life. As Martin Buber once said, "In strict logic 'A' cannot equal 'not-A.' But in lived life, this is often true."

Life just doesn't often neatly fit our rational categories.

Dream of Wet Pavements is an attempt to evoke this complexity and mystery—that the very place of selfishness, destruction, and misery can also be a place of fruition, beauty, and creative selflessness. The images that suggested themselves to me all contained a baptism of sorts—a cleansing and rebirth in the most pervasive of elements on our planet: water.

More than 70 percent of the earth's surface is covered by water; thus water is the major symbol of hope and of new possibilities, not just of deluge and destruction. In chapter 9 of Genesis, God promises Noah that the earth will never again be completely destroyed by water. Afterward, the people of Israel are several times miraculously led through watery wastes as on dry land. In the New Testament Christ's word calms the turbulent sea, and water later becomes a symbol of regeneration for believers in and through Holy Baptism.

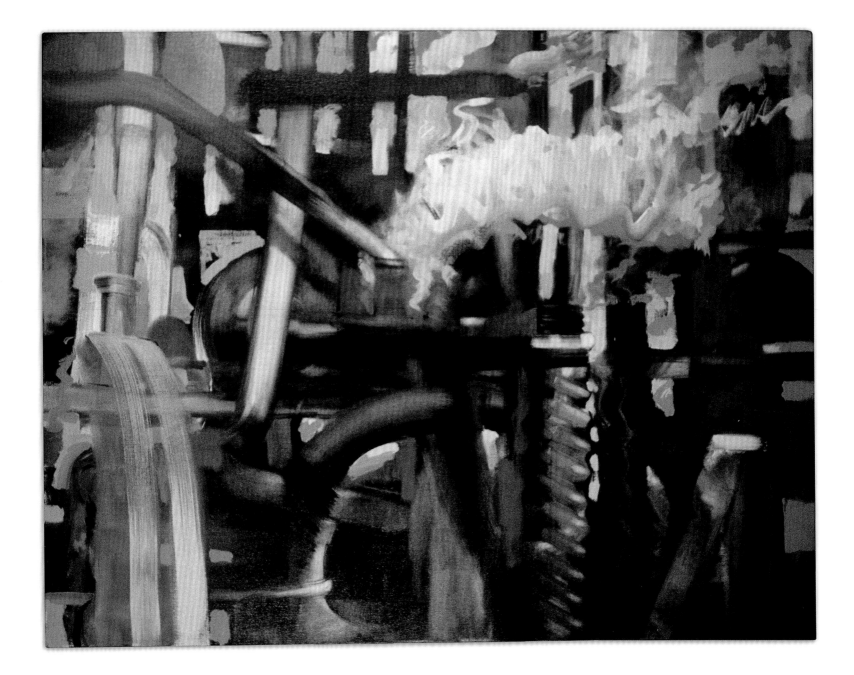

fig. 22. *Steam & Light* (from *Dream of Wet Pavements*) © 1989 Bruce Herman; oil on canvas, 40" × 60"; collection of Tony Merlo

Is this a sign of being out of step? Actually, I think it is more that, as an artist, I am constantly feeling my way in the dark—and many times I find that the images I feel drawn to create seem to evoke an as-yet-unrealized state of things.

In the first two paintings of *Dream of Wet Pavements* (fig. 18 and fig. 19), a waterfall miraculously appears at the top of tall buildings, wetting the streets and buildings and creating a mysterious atmosphere. In the second of these, *Dream of Wet Pavements II*, there appear ghostly human/angelic presences—akin to the angels in Wim Wenders's film *Wings of Desire* and inspired by the biblical testimony of John in Revelation, where two "witnesses" attend to the last things as awesome events unfold.

These two shadowy witnesses show up in several paintings from this period of my work. They are particularly prominent in the piece titled *All Attempts to Restore Order* (fig. 16), a painting that I destroyed by over-painting, eventually settling on the image *The Man & the Machine* (fig. 17).

In the first state of *All Attempts*, the two figures were present in a congested urban setting that revealed a temple-like hall of justice (or injustice) and a conveyor belt or train track surmounted by a flat-bed car/machine dragged by a naked man. The man strains at a rope and lever, trying to move the contraption forward. On the flatbed car were two female nudes with their backs to the viewer—courtesans as commodities? Everywhere there was a leaden light, a luminous darkness. In the distance, perched on a wall, was a small naked female figure looking over a parapet toward the city.

This same female figure appears again in another piece, *Witness Wall* (fig. 20). Like the two witnesses, she is almost faceless—an Anybody or Everywoman.

When I over-painted *All Attempts to Restore Order* with what eventually became *The Man & the Machine*, I simply turned the painting upside-down and painted out more than half the image, saving only the cogs and wheels and pistons of the Machine while introducing a very different quality of light—a bright, highly saturated color—and a prominent Christ figure against an electric blue. The Christ figure is crucified, yet without an actual cross. The figure is simply floating, cruciform, near or on the Machine and seems about to be submerged in . . . is it water again?

As I write it is now almost a quarter-century ago that I created these images, and in many ways they seem to have been made by another artist. Yet I find that certain aspects of these pieces seem to re-emerge in my current work—mostly in the form of abstract passages or implied spaces that have a vaguely architectonic feel to them. I think if I were to revisit this sort of image now, with more than twenty years intervening, I would in all likelihood paint something less dark or ominous . . . which is strange given the turn of events in recent years—world-wide financial collapse and the widespread economic despair that seems always to loom on the near horizon.

Is this a sign of being out of step? Actually, I think it is more that, as an artist, I am constantly feeling my way in the dark—and many times I find that the images I feel drawn to create seem to evoke an as-yet-unrealized state of things.

The "Spirit" of the City

In times past it was believed that spirits inhabited and had oversight of cities—hence the "Spirit of St. Louis" as a linguistic vestige. Inhabitants of the ancient kingdoms of Egypt, Assyria, Persia, and Greece (along with Christians' ancestral co-religionists, the Jews) believed that spirits or angels were behind most everything, but particularly great cities. The cities, as great gathering points of persons and potentialities, seemed to be overseen by particularly strong spirits, called "principalities and powers" in the Bible (the "prince of Babylon," the "prince of Persia," and the "prince of Assyria" refer in biblical tradition to presiding angels or spirits).

In our own time cities have become not only great gathering points but also centers of global technological prowess. Huge Internet servers contain microchips and logic boards teeming with information and communications of every sort that ceaselessly pour over the surface of the earth and through the "air" or "cloud" of satellite beams and radio waves. These servers are analogous, I think, to the principalities that were once believed to oversee the spirit-realm and the affairs of humans. The so-called "prince of the power of the air" might easily be seen today as the presiding "angel" of the Internet. It may be too easy to quickly associate the devil with technology—as did the early opponents of the steam engine and the telegraph. But I think it is helpful to keep in the back of our minds the potential

insight offered by the seemingly quaint associations inherited from our various cultural traditions.

That insight glimpses the power that hovers over large gatherings of people—the sense of a "group mind" that descends on a crowd unified by a single voice (demagogues like Stalin or Hitler or Mussolini) or by a powerful personality or performer (a U2 concert is a positive example). This phenomenon is ancient yet utterly contemporary. When technology welds together large groups of persons (through television, cinema, and certain aspects of the Internet, for example), a similar uncanny, unifying effect occurs. At the very least technology can create a mass-consumer culture.

But how is technology linked to our ancient sense of tribal spirits, of group identity at the experiential level? One aspect, I think, is the way that electronic communications in particular seem to offer a satisfying sense of "connecting"—of communing. The root word of communication, communion, and community is the word *common*. Having things in common yields the experience of unity—common-unity or community. The Internet affords us an unequalled experience of sharing things in common, the democracy of information and "connection." The very word *connection* has become an electronic reference. To connect is to tie into the source of energy and power.

With the technological revolution of the past thirty years, we are seeing something Plato only imagined: a virtual community of minds that does not necessitate a physical presence or incarnate limitation. With the advent of the Cloud and the increasingly "virtual" realm, there is no need for physical presence—one can

simply communicate via the electronic "avatar" one constructs on the Internet.

Ray Kurzweil (a pioneer of speech-recognition software and artificial intelligence) has produced a film and book about the future, titled *The Singularity Is Near*, which imagines a final frontier of technology when human and cybernetic fuse. At this point we leave behind forever our limitation of mere physical existence—a looked-for "next step" in evolution, the so-called post-human. According to this trend in some current thinking, in the final frontier of technology, *techne* forever outstrips *sophia* (wisdom); our capacity for manipulation overcomes our capacity for ethical and spiritual understanding.

My painting groups *Spirit of the City*, *Man and Machine*, and *Dream of Wet Pavements* all aim at the crux of these issues: the intersection of hand and heart, wisdom and craft. The series that followed, *Building in Ruins* (see chapter 6), also explores this arena of culture—the simultaneous building and destroying that we are always engaged in—and the subtle evidence that the City of God is always breaking in on the City of Man.

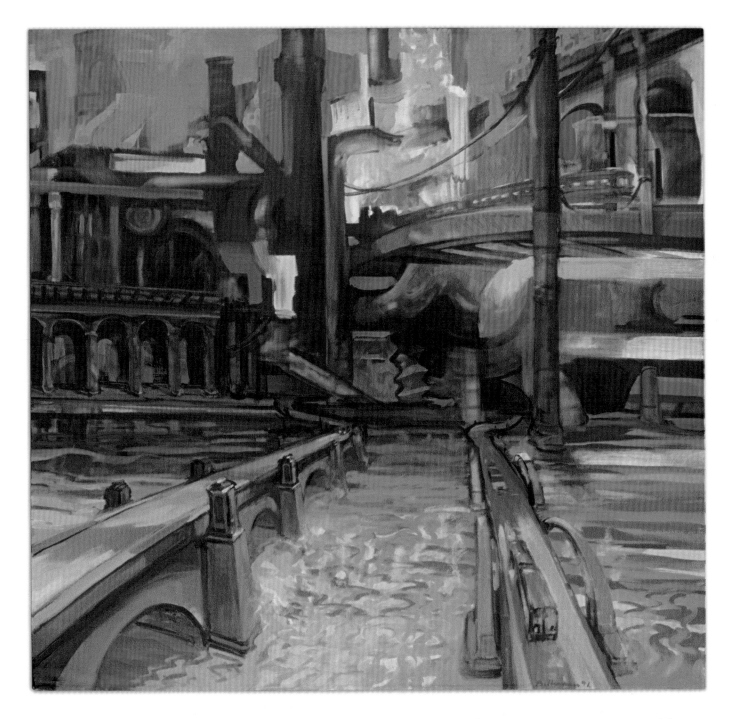

fig. 23. *Inbound* (from the series *Dream of Wet Pavements*) © 1989 Bruce Herman; oil on canvas, 55" × 55"; courtesy of the artist

On Sacred Imagery

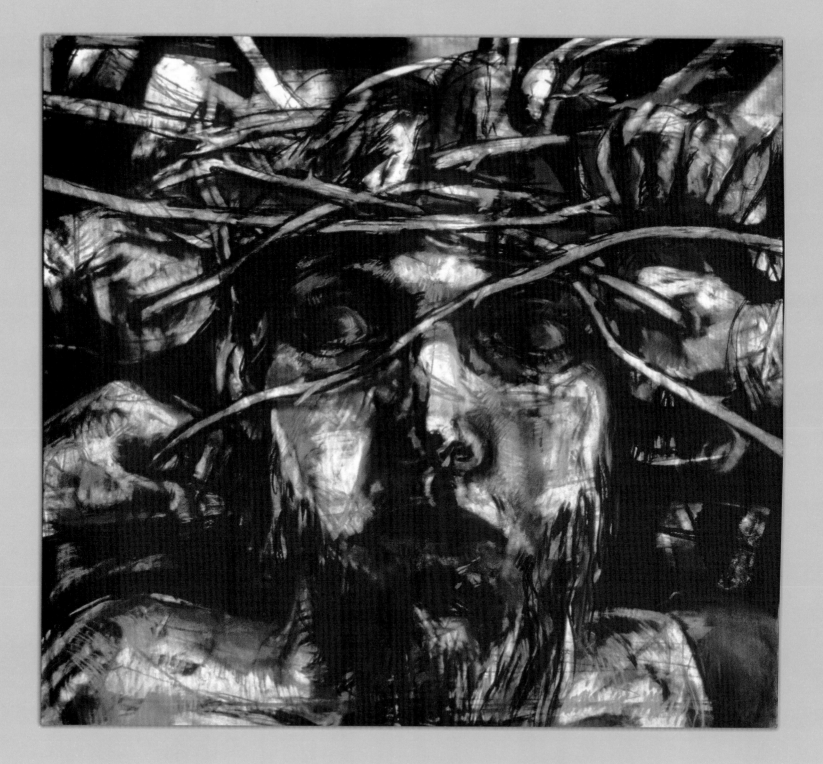

On Sacred Imagery

Golgotha

In 1990, just around the time I felt the cityscape series coming to an end, I had the thought that perhaps I could find a way to serve my local Christian church as an artist—possibly to try my hand at biblical narrative images or to make art for worship. I approached our pastor, my good friend Gordon Paul Hugenberger (now senior minister at Park Street Church in Boston), and asked if he'd be willing to attempt a Good Friday service with art, music, and Scripture and poetry readings.

He was very encouraging and gave the go-ahead to begin planning. I approached three friends of mine who were involved in the arts locally: the writer Patty Hanlon, the jazz composer John Rapson, and the filmmaker/songwriter Paul Van Ness. Between the four of us, and in cooperation with Dr. Hugenberger and others in the congregation, we developed readings, images, songs, and a jazz-inflected solo trombone meditation on the Passion of Christ.

My paintings were loosely based on the traditional Stations of the Cross, drawing very much from the stylistic thrust of Expressionism—exaggerated form, strong color, and violent marks of the brush and pastel chalks—to evoke the hardship, suffering, and agony of Jesus on Good Friday. Patty Hanlon's narratives and Paul Van Ness's poignant songs were deeply stirring that night, Friday, March 29, 1991. It was a memorable and moving evening—especially John Rapson's mournful trombone solo at the end of the service, which pierced our hearts. The church was filled to the brim with our congregation and with visitors from Gordon College and the nearby community. I think it was the first time I felt that our little congregational church entered into a ritual of this sort. It was deeply fulfilling for us as artists—to be allowed to serve with our gifts and to build up the body of believers in their holy faith and love for Jesus.

fig. 25. *The Crowning* (from the series *Gologtha*) © 1991 Bruce Herman; pastel on handmade Dutch cotton paper 38" × 46" collection of Ed and Margaret Killeen

My paintings were loosely based on the traditional Stations of the Cross, drawing very much from the stylistic thrust of Expressionism.

Cam Anderson's introduction to this book mentions one of my paintings in the *Golgotha* series, *The Flogging*. That piece was one of more than twenty that I was led to make over a year or two, many of which were used in that Good Friday service and later incorporated into the book *Golgotha: The Passion in Image and Word*. All the works from this series are, as I said, expressionistic. My reason for avoiding "realism" is that the suffering of Jesus on that day would be too horrible to portray realistically; and ironically the stylized, exaggerated style of Expressionism allows the viewer (and the artist) to step back from the agony and horror and yet to feel something profound about Christ's ordeal that day.

I hope the reader and viewer of this book can understand why I chose to make these distorted, painful images. Somehow they combined with Paul Van Ness's tender songs, Patty Hanlon's deeply affecting narratives, the testimony of Scripture, and John Rapson's wailing trombone to make a worship service that opened our hearts and minds afresh to the costly grace given us in the cross of Christ.

Portraits of Our Redemption

Several years later I approached Pastor Hugenberger with another idea for ecclesial art: a set of mural-sized paintings I would complete in collaboration with him, the biblical teacher-preacher of our church. Intrigued, he welcomed the idea and began offering suggestions for our work together.

Dr. Hugenberger taught Old Testament at Gordon-Conwell Theological Seminary at the time, and he is something of an expert in biblical typology, particularly of Christ in the Old Testament (pre-Incarnation theophanies and type/antitype relationship of the judges of Israel and Christ as the fulfillment of Old Testament prophecy). He suggested we attempt two or three key passages in Genesis and Exodus and then concentrate on the judges—characters he teaches as prototypes of the Messiah, the "Second Moses" prophesied in the Bible.

I loved this plan and immediately began envisioning how I'd do these paintings for a site-specific installation at this nearly-two-hundred-year-old clapboard-style New England church building. This was possibly the most exciting project I'd taken on to date—because it combined several deep interests of my own as an artist with a real need in the Christian church. The encouragement that I received from Pastor Hugenberger was life-giving; it motivated me to take my art to a higher level both in terms of content and form.

Below is a very brief description of two of the eight paintings, as well as a diagram of how they were laid out in vertical triptych format.

The Triptychs

Each of the eight large paintings in the Lanesville Murals forms a vertical triptych—that is, a three-panel image in which the separate panels "comment" on each other, amplifying the iconography or symbolism and explicit or implicit narrative. In the very first piece that Gordon Hugenberger and I collaborated on, we settled on the "Expulsion from Eden"—a traditional subject in European art, often depicting Adam and Eve naked and horrified as they are ejected from paradise (fig. 27). Our interpretation of the Genesis 3 passage differs radically from that

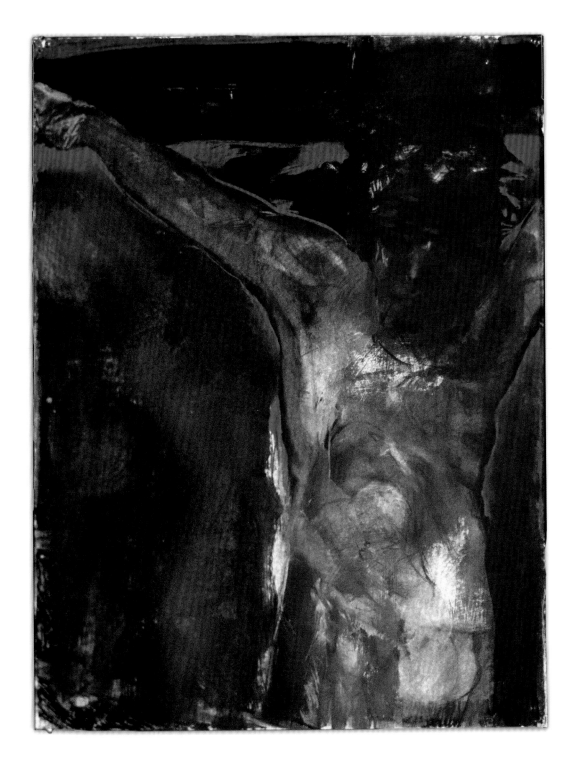

fig. 26. *Night* (from the series *Gologtha*)
© 1991 Bruce Herman; pastel on handmade
Dutch cotton paper 60" × 46"; collection of
The Stonybrook School

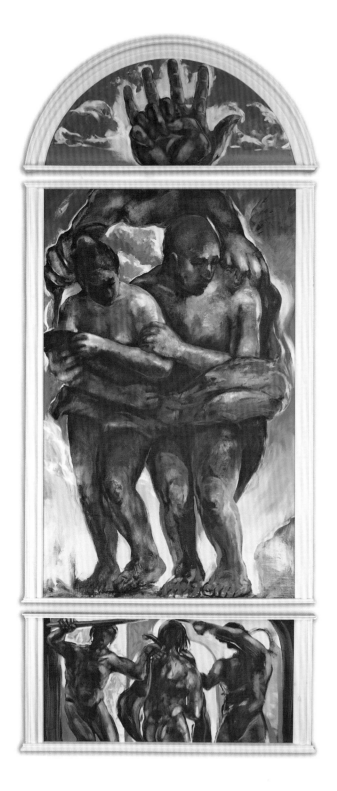

traditional scene: in the large middle panel the viewer sees Adam and Eve embracing and being protected and clothed by their Creator—and sent out (rather than expelled). They are clothed in "skins" (as the biblical account says), and the symbolism of this clothing or covering is later unpacked by Scripture: whereas they were unable to cover up their disobedience in grasping for the forbidden thing—pathetically sewing fig-leaves for clothing—the Lord covers them and their sin by sacrificing their former companions (the animals) and giving them a literal propitiatory covering. The Lord also sends them out of the Garden to protect them from eating of the Tree of Life and thereby living eternally separated from the perfect will of God, like the fallen angels.

This image and its interpretation fly in the face of centuries of Christian tradition in biblical illustration—wherein the notion of punishment is central. Our image instead emphasizes Israel's pattern of inheritance law: you make a symbolic and sacrificial coat and cover the one you plan to bequeath an inheritance to. And the origin of that tradition, according to Dr. Hugenberger's exegesis, is God's perfect covering of sin intimated in the Garden and perfectly fulfilled in the suffering of Christ, which we see depicted in the bottom (predella) panel. Whereas Adam and Eve are clothed and protected, Christ is stripped and beaten by the Roman guards, taking the very punishment due to Adam.

The "Second Adam" is the true and final covering for Adam's and our sin, and the topmost, semi-circular panel (lunette) depicts the open, merciful hand of God behind the fist of judgment and wrath that is the righteous and fitting response to sin. So God

fig. 27. *In Wrath, Remember Mercy* (from Lanesville Murals) © 1997 Bruce Herman; oil on wood panels; 126" × 50"; collection of the artist

is both righteous in his judgment and merciful in his perfect covering and provision.

Each of the eight vertical triptychs in the Lanesville Murals shows this same sort of typology. Whereas Abraham is tested and ultimately not required to offer up his only son; God must offer his only son, Christ Jesus, who is shown in the lower predella panel to have been sacrificed for us (fig. 28). Isaac is spared, but Jesus suffers in his place—just as Adam and Eve had been spared and protected and Christ suffered in their (and our) place.

The two-year project with Dr. Hugenberger was a highlight of my growth as an artist of Christian faith, and I feel so very grateful for that time to work with a first-level biblical scholar. In many ways I think that is what is missing for artists in the church—a welcome from pastors and teachers to be full co-laborers in the work of building up the body of Christ through love and rich visual meaning. In an image-drenched culture such as our own, this may be one of the best antidotes—to bring visual thinking and making under the authority and gracious umbrella of the church. More could be written about this, but I will leave it here by simply saying that my experience was deeply meaningful and encouraging; I felt that, finally, my gifts as an artist seemed needed.

Studio Fire of '97 and *The Body Broken*

In early autumn of 1997, just after the completion and final installation of the Lanesville Murals, *Portraits of Our Redemption*, at our church, lightning struck and

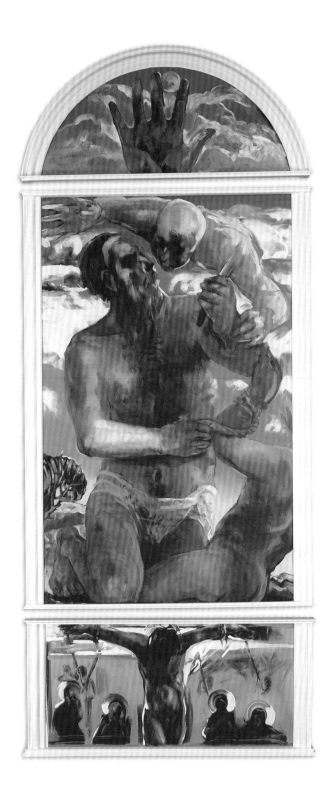

fig. 28. *God Will Provide* (from Lanesville Murals) © 1997 Bruce Herman; oil on wood panels; 126" × 50"; collection of the artist

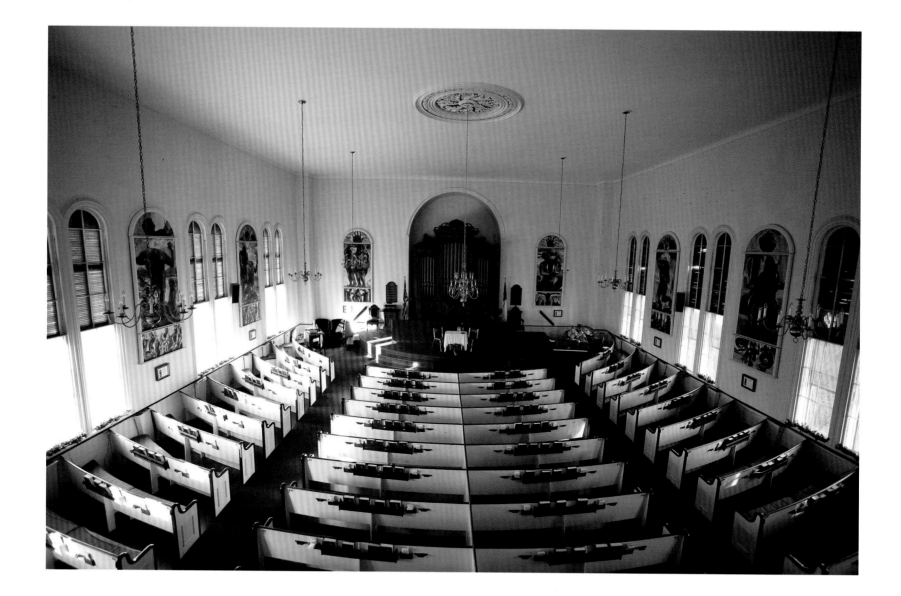

fig. 29. Installation view of Lanesville Murals *Portraits of Our Redemption* at the Orthodox Congregational Church of Lanesville, Gloucester, Massachusetts; all works collection of the artist; © 1997 Bruce Herman; oil on wood panels; each of eight triptychs is 130" × 50"

burned my house and art studio, destroying nearly all of my artwork and necessitating the tear-down of the house and studio. Aside from works already in circulation in private or public collections, the sole surviving paintings were from the *Golgotha* series (because they had been moved the day before the fire) and the Lanesville Murals (because they were installed in the church miles away).

The house fire soon became a marker for me—a passage into a new phase of my life as an artist and believer—and the next several groupings of paintings I made were all affected by this time of loss and rebuilding. I found my color palette changing and the subject matter becoming more and more intense and focused—and my technique more developed toward subtleties and softer, warmer color and subtler form. It was almost as if the fire had refined something deep inside me, burning away superficialities and elements in my work that depended on influences I no longer needed. I felt strangely liberated, and I began to "rebuild" quickly by making several whole new groupings of works—among these the series titled *The Body Broken*.

In that new start I felt drawn again to specifically religious imagery, but to more allusive and indirect means of getting at a religious vision. In *The Body Broken* paintings I attempt to investigate the post-biblical epoch of early church history in which individuals were called to be *alter christus*—literally "other christs" whose lives, like Jesus', were laid down in martyrdom. These martyrs, unlike modern-day suicide bombers, witnessed to Christ's love and sacrifice through loving and forgiving their tormentors—often even as they were being persecuted and murdered by violent means. St. Stephen was the prototype, asking forgiveness for his murderers even as they were stoning him to death (Acts 7:58–60, ESV):

> Then they cast him out of the city and stoned him. And the witnesses laid down their garments at the feet of a young man named Saul. And as they were stoning Stephen, he called out, "Lord Jesus, receive my spirit." And falling to his knees he cried out with a loud voice, "Lord, do not hold this sin against them." And when he had said this, he fell asleep.

The broken bodies of this "cloud of witnesses" became for me a symbol of the brokenness of this world, the ruins of our lives (in some cases quite literal, as in our house fire), and the need for grace and forgiveness and magnanimity. I painted several historic martyrs such as St. Perpetua and St. Felicitas.

Perpetua was a high-ranking woman of Rome and a convert in the third century. She and her servant Felicitas were killed for their public confession of Christian faith in Carthage in 203,

fig. 30. *Annunciation* (from the series *Body Broken*) © 2002 Bruce Herman; oil on wood, 72" × 96"; collection of William and Ellen Cross

fig. 31. *Elegy for Bonhoeffer* (from the series *Body Broken*) © 2001 Bruce Herman; oil on wood, 72" × 48" ; collection of Messiah College

fig. 32. *Elegy for St. Thérèse of Lisieux* (from the series *Body Broken*) © 2006 Bruce Herman; oil on wood, 72" × 48"; collection of Stephen and Denise Adams

under the North African rule of Septimius Severus. I also painted St. Christopher—patron saint of travelers and an historic martyr of Rome—who had the job of carrying people across the River Tiber because of his great height (over seven feet tall) and who is said to have had a vision of carrying the Christ child during which he himself was actually carried instead. I attempted in this series to look at the way the bodies of these saints were transfigured in their self-sacrifice and made to become truly "broken for you" just as Jesus had been. I extended the time-frame to include modern martyrs by painting *Elegy for Bonhoeffer* (see fig. 31)—who lost his life to the Nazis for resisting their lies and violence and genocide of the Jews and gypsies.

This series naturally led me back to the theme of the City—since most of these martyrs were killed for their faith in the major urban centers of human culture.

Somehow I found it fitting to be meditating on these figures after our fire, and even more fitting to return to the theme of

rebuilding by faith amongst the ruins and wreckage of human culture—bearing witness to the hope of the gospel in our times. I painted *Annunciation* (fig. 30) as a meditation on how the Virgin Mary might be seen in the midst of the siege of Sarajevo or some such modern-day massacre like the one that attended Jesus' birth. I began stretching the metaphor of the City to encompass both the conflict and politics of contemporary life and also the spiritual reality of bearing witness to the timeless love of Christ. *Elegy for St. Thérèse of Lisieux* (fig. 32) is meant in this same way (as a poem for the dead). The image is dedicated to the embrace of compassion and forgiveness exemplified in the life of another modern saint, Marie-Françoise-Thérèse Martin. Her sweet and magnanimous spirit has inspired millions to live for Jesus by small, daily devotional service and dedication to seeking the holy face of Christ and by devotion to the childhood of Christ, wherein God displayed his glory in weakness, powerlessness, and brokenness.

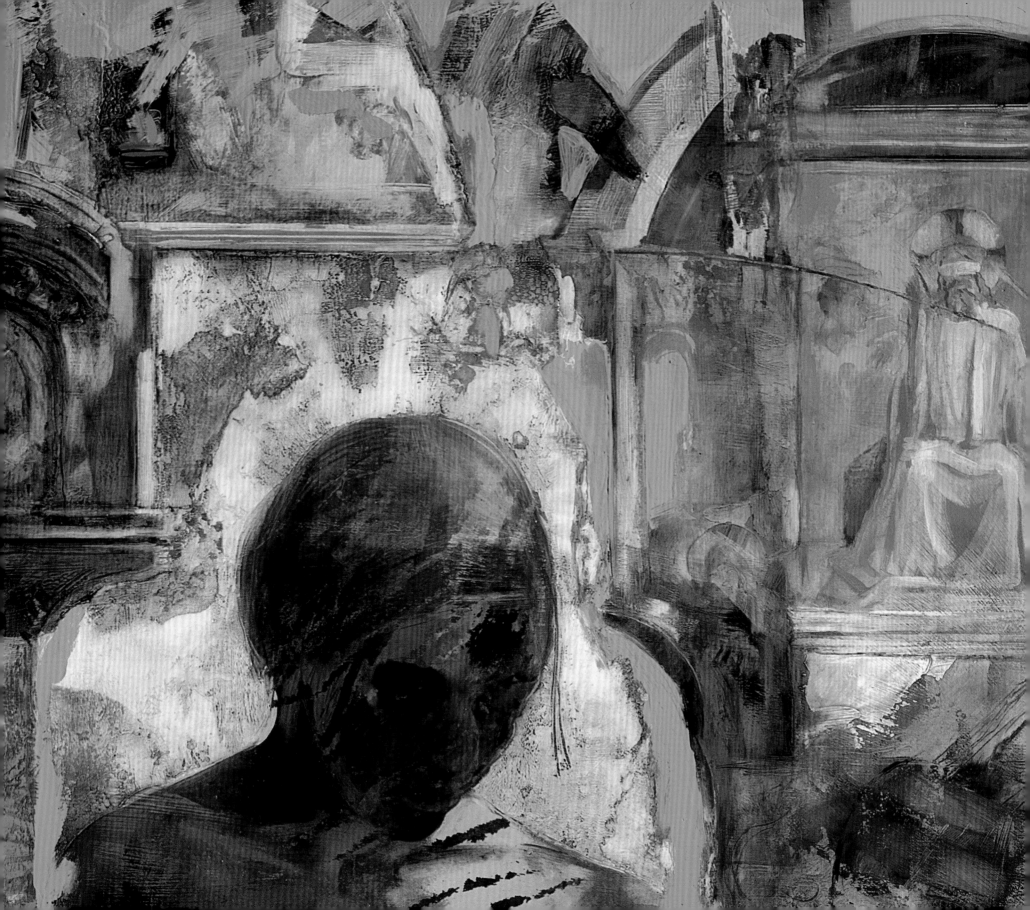

Building in Ruins

fig. 33. detail: *Passion* (from the series *Building in Ruins*) © 2001 Bruce Herman; oil on board, 48" × 36" ; collection of Grant and Sandi Lowe

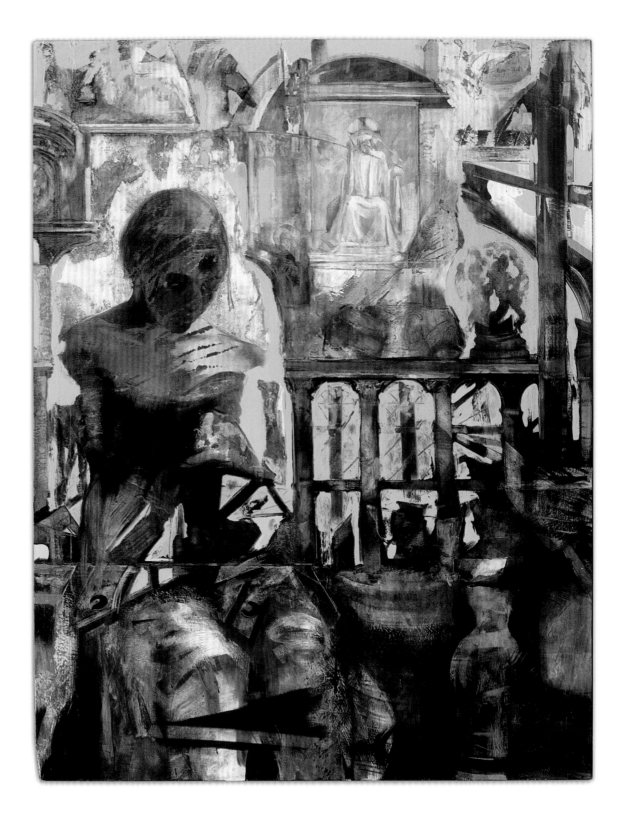

Building in Ruins

B. Herman

We moved from Boston back to Gloucester in the 1980s, eventually settling on a quiet side street that cuts across the tidal marsh on Walker Creek. I made my art studio in a makeshift space behind our horse barn and beside a little brook that ran under the road and across our property, feeding into the larger tidal creek—an idyllic spot by any measure. Ironically it was in that sweet pastoral setting that I painted the *Wet Pavements* cityscapes—fairly portentous urban images—instead of recording the beautiful countryside nearby. These darker urban images just "came" to me. I seldom follow a conceptually rigid plan in the studio but, rather, paint what suggests itself to me long after my research on a given subject has run its course. I read, reflect, travel, and engage in careful study— but when I enter the studio to paint, I try to forget all that. I attempt to disappear into the act— abandoning the intellectual grid in favor of a more contemplative, spontaneous exploration of form. I've found the most fruitful imagery comes to me when I am least inclined to "illustrate" an idea or concept or theme.

In the late '90s, after our fire and after completing the martyr series (*Body Broken*, chapter 5), I found myself returning to a quasi-urban imagery of architectural ruins with ambiguous figures and fragments from Italian sacred art tradition—bits of Fra Angelico murals, a random archway, columns or trusses supporting nothing or simply standing as a reminder of a former wholeness. If the *Dream of Wet Pavements* series (chapters 2 and 3) was a kind of meditation on the City of Man, the *Building in Ruins* series was a broken attempt to point toward the City of God.

The human city runs the gamut of paradox and conundrum: it's a gathering of all that is most beautiful and creative and hopeful in the human family, and it is also the site of the most baleful and ugly and miserable. The Bible commands us to pray for the prosperity of the city—even the oppressive city of Babylon. As Walter asks in his reflections in chapter 1 (on *Rome: A Vision*), did

The human city runs the gamut of paradox and conundrum: it's a gathering of all that is most beautiful and creative and hopeful in the human family, and it is also the site of the most baleful and ugly and miserable.

fig. 34. *Passion* (from the series *Building in Ruins*) © 2001 Bruce Herman; oil on board, 48" × 36" ; collection of Grant and Sandi Lowe

not Jesus weep for Rome as well as Jerusalem? I discovered in this new painting series a way of showing glimpses of the New Jerusalem shining out of the ruined, humanly wrought architecture of our failed urban dreams.

Building in Ruins combines the fragmented human forms of the martyrs in *Body Broken* with the architectural forms of *Wet Pavements* to cast a vision of possibility and beauty out of the ashes of human loss and brokenness. One of the pieces in this new series, *Passion* (fig. 34), is dominated by a young woman's form on the left side of the painting. She is beautiful but badly scarred. In fact the painting itself is scarred and torn across the surface of her face and figure. Part of her body is missing entirely, and the viewer should read this as an indicator that she herself *is* a painting—literally a painted fragment on a busted wall. To her left, on the right-hand side of the image, is another wall mural fragment, this time a quotation of a famous Fra Angelico meditation cell from Monastery San Marco in Florence, Italy: *The Passion of Christ*. The young woman seems lost in contemplation, and she seems to occupy the room in which the Angelico painting once stood. However this image is interpreted, I hope the viewer encounters the hope that these colors and broken forms evoke in me.

With the reintroduction of the human form amid the ruined architecture, I was trying to move toward an imagery of "rebuilding the ancient devastations" (Isa. 61:4, NASB):

> Then they will rebuild the ancient ruins,
> They will raise up the former devastations;
> And they will repair the ruined cities
> The desolations of many generations.

While we were still rebuilding our own lives following the fire, I found that painting images of hope and healing amid wreckage seemed fitting. Another example from the new series was *Against Chaos* (fig. 21, discussed by Walter in chapter 3). It's a large piece—72 inches high by 48 inches wide—and contains a heap of wreckage and architectural ruins with a male figure perched atop the rubble. The figure holds some sort of surveyor's rule or architect's instrument and seems to be judging an angle or measuring some aspect of the scene. The pile of rocks and architectural fragments seems unpromising and may resemble a modernist painting or sculpture that has been shattered. In the distance is what appears to be a Greco-Roman temple or some such building, and surrounding the man is a luminous framework or scaffolding. The pervading mood is not melancholy but cheery—almost glowing. The image and the formal elements

(color, texture, composition) seemingly contradict each other. Needless to say, all this is intentional on my part.

Without trying to force an interpretation—rather, wanting to offer an invitation to reflect together—I'll simply say I was attempting to paint an image of genuine hope . . . —but not blind optimism. The man might easily be any one of us; and though his situation is not comfy and triumphal, he seems to be seeking a solution, a design, a means of making meaning or at least actively surveying his world. The "former devastations" are really a place of potential—not morose self-pity or degradation.

By surveying the real situation, this figure appears ready to step off the rubble pile and into the possibility before him. This painting could well be used as a skeleton key for the entire *Building in Ruins* series. There are shared elements with each piece in the group: scaffolding (often luminous and colorful); fragments (often piled or strewn); a human presence that is both contemplative and active; bits of traditional architecture or iconography; and allusion to the sacred art and architecture of the past.

Nowhere in the series is there a sense of foreboding or the ominous darkness that seemed to hover over the *Wet Pavements* series. The color is uniformly bright, saturated, with active brushwork. The figures are all involved in contemplation, but they are also actively engaged with their environment. There is a prevailing mood of reflection but also imminent action— possibly rebuilding from the scrap heap. If I attempted anything conscious in this series, it was to make images that functioned both formally (as aesthetic experiences in their own right) and as images of hope and healing in our broken and often confusing contemporary situation. I wanted to avoid anything preachy or didactic. I wanted more than anything to get at the sense of mystery and possibility I see in our times despite the wreckage everywhere.

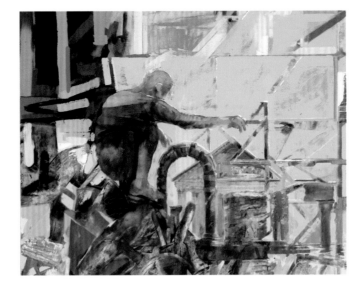

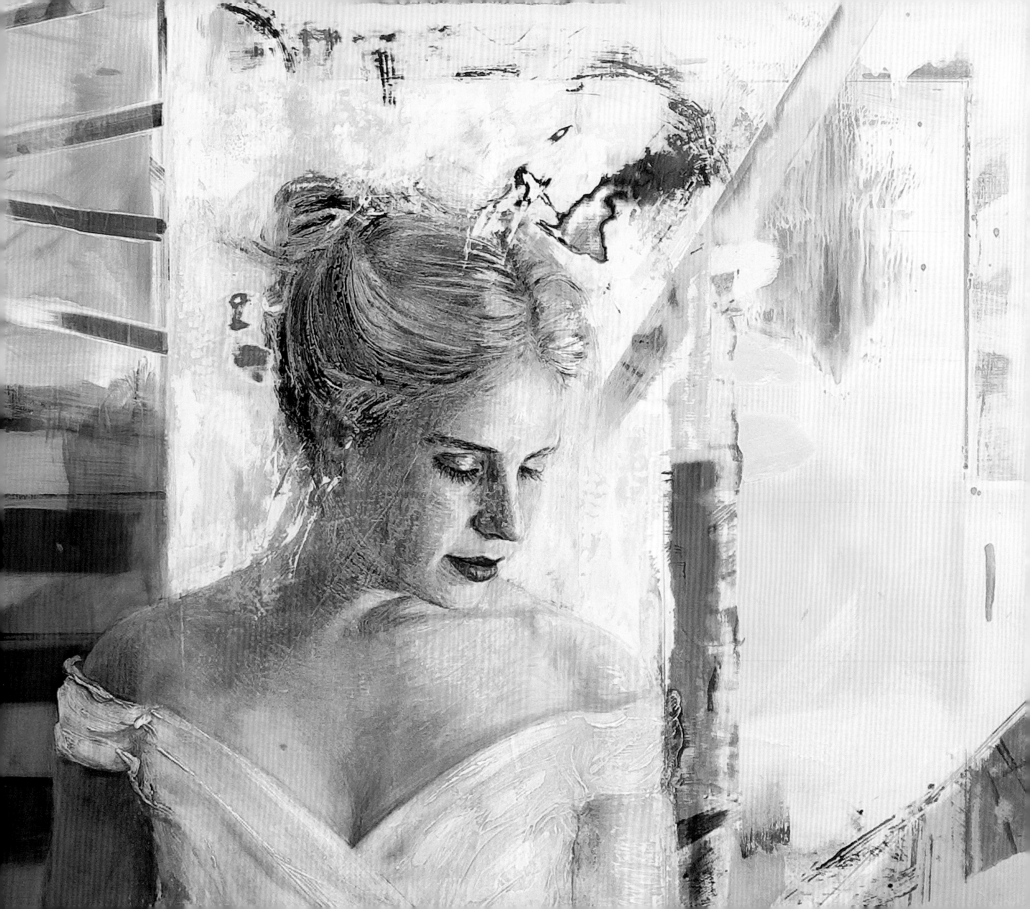

Betrothed

fig. 35. detail: *Betrothed* © 2006 Bruce Herman; oil on canvas, 65" × 48";
collection of Walter and Darlene Hansen

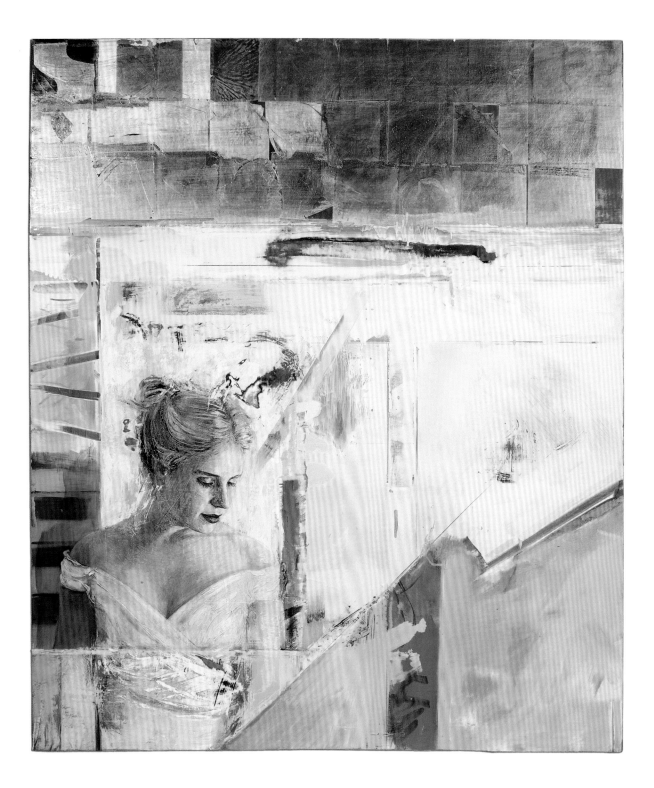

Betrothed

SW Hansen

Betrothed rises to newness of life!

Her downcast eyes, slight blush, swept-back hair, and closed lips express her purity. Her bare shoulders and formal wedding gown speak of her availability, but only to the bridegroom. She does not engage me like Mona Lisa, who follows me with her eyes and enchants me with her smile. Yet Betrothed is not cold or distant; she radiates warmth and energy; she attracts attention without seducing. She is on the verge of raising her head, opening her eyes, smiling, and bursting into an aria.

Betrothed is coming up out of water. Since the stripes of gray and white beside her signify the Duomo in Florence, the Cathedral of Santa Maria del Fiore, I interpret her rising from the water as the event of her baptism: she is united with Christ in baptism, buried into death with him, so that as Christ was raised from the dead, she too might be raised to newness of life. Raised incorruptible, she radiates the new life beyond death.

She is in the church; she is the church. She is also in the world. On the other side of her, the loose, broad brushstrokes of earth colors place her in nature. She rises from the earth; she is earth permeated by Spirit. The wedge of earth grounds her, locates her in the human family, for the human family.

Above her the sky blue gives way to the unbearable weight of glory: the gold-leaf heavens bear down upon her. The golden heavens tell of her inner beauty. The pain she bears as a member of the human family produces within her the eternal weight of glory. Yet even this heavenly golden beauty is broken, marred, and scarred by slashes of red. Pain—or at least memories of pain (do I see a nautilus shell etched there?)—perfects the pattern of gold leaves. Eternity envelops but does not erase time.

Betrothed rises to newness of life.

For years I looked at a portrait of the same young woman in Bruce Herman's painting *Memory and Origins*. When we moved from Santa Barbara to Chicago, we lost that painting. On Good Friday, movers discarded the boxed painting of *Memory and Origins* in a dumpster: she was buried in a landfill near Rockford, Illinois. A "discarded Image" was lost and buried.

On Easter Sunday, Resurrection Day, we acquired *Betrothed* from the artist. The image sown in dishonor was raised in glory.

Betrothed lifts me to newness of life.

fig. 36. *Betrothed* © 2006 Bruce Herman; oil on canvas, 65" × 48"; collection of Walter and Darlene Hansen

fig. 37. *Memory and Origins* © 2005 Bruce Herman; oil on wood, 48" × 36" (lost in transit/destroyed in Hansen move to Chicago)

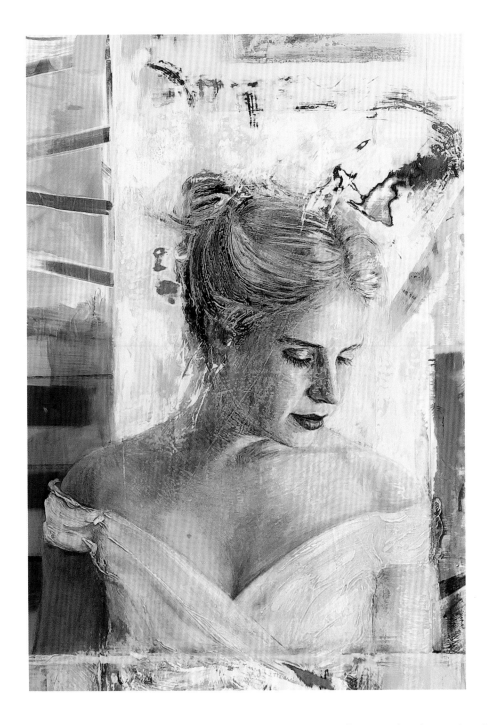

fig. 38. detail: *Betrothed* © 2006 Bruce Herman; oil on wood, 65" × 48"; collection of Walter and Darlene Hansen

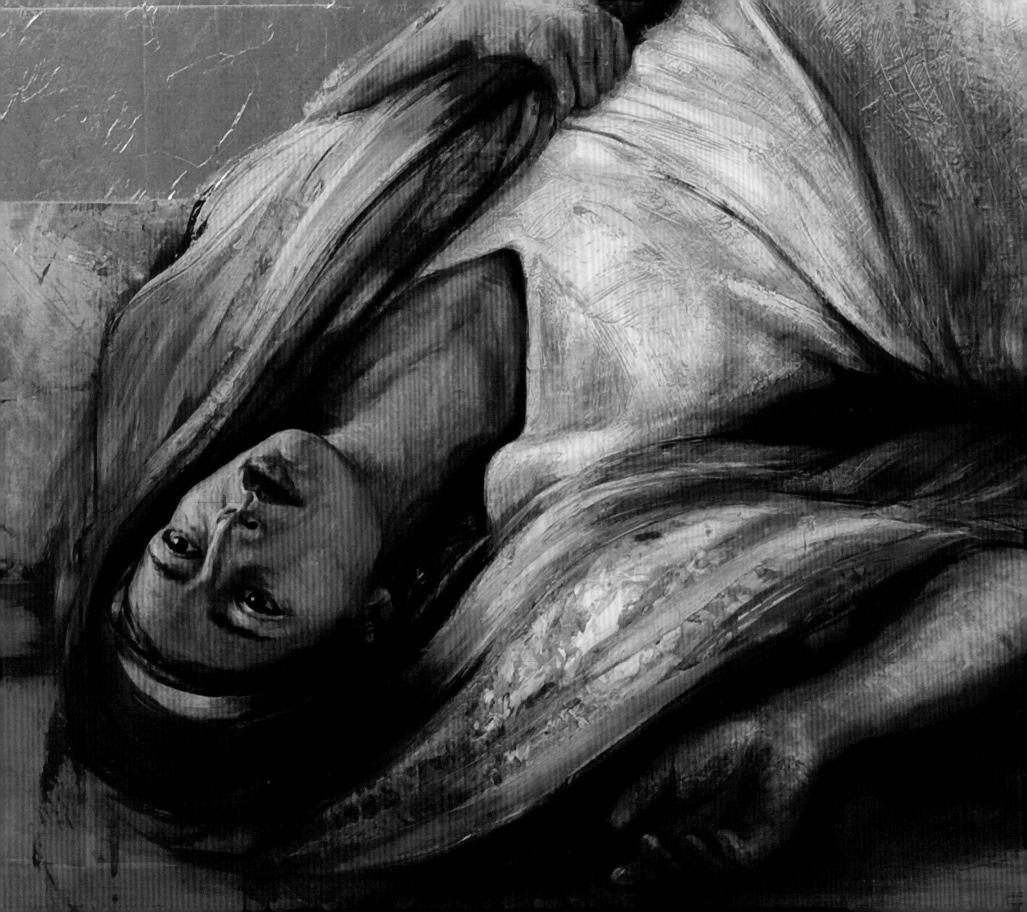

Magnificat

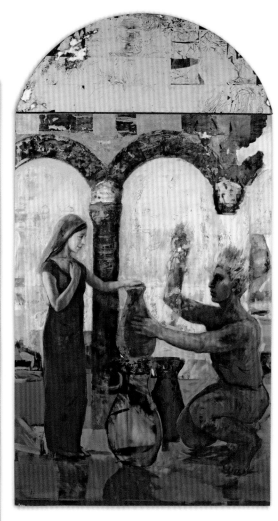

Magnificat

[signature: SW Hansen]

On the *Miriam, Virgin Mother* Altarpiece

When I look at Bruce Herman's triptych *Miriam, Virgin Mother*, I am disturbed and at the same time delighted by its narrative of events that overturn the powers of our world.

Watching the story unfold from right to left in good Hebraic fashion, I first see an invasion from outside our world: a messenger materializes before my eyes. His right arm raised in a salute has not yet fully arrived. His hair still stands upright from suddenly swooshing into Mary's presence. Kneeling before her, he places his hand on the belly of the vase, symbolically signifying his message: "Do not be afraid, Mary; you have found favor with God. You will conceive and give birth to a son, and you are to call him Jesus. He will be great and will be called the Son of the Most High. The Lord God will give him the throne of his father David, and he will reign over Jacob's descendants forever; his kingdom will never end" (Luke 1:30–33).

Mary, calm and elegant, covers the top of the vase with her left hand and her heart with her right hand, signifying that she diligently guards her virginity. She simply asks, "How will this be, since I am a virgin?"

Gabriel, the disturber of order in Mary's world, tells her how the virgin conception of her son will be accomplished: "The Holy Spirit will come on you, and the power of the Most High will overshadow you. So the holy one to be born will be called the Son of God" (1:35).

In Bruce's visual retelling of this event, the Roman arches—symbols of the mighty Roman empire—are already disintegrating, collapsing under the overarching golden dome of heaven. The brilliant

Watching the story unfold from right to left in good Hebraic fashion, I first see an invasion from outside our world: a messenger materializes before my eyes.

fig. 40. *Magnificat—Miriam, Virgin Mother* © 2007 Bruce Herman; triptych, oil with 23kt gold leaf on wood, 95" × 154"

fig. 41. *The Visitation* (Mary greets Elizabeth) from *Magnificat—Miriam: Virgin Mother* © 2007 Bruce Herman; oil with 23kt gold leaf on wood, 80" × 48"

This event, as Bruce visualizes it, takes place in heaven: surrounded by gold, Mary lies prostrate in the presence of God. Her eyes look up into the eyes of her Lord. As I view her, I feel disoriented; my world is askew. No matter how much I twist and turn I am not aligned to her vision. She is perfectly aligned to the Word of God: "May your word to me be fulfilled," she says to the angel (v. 38). And the promise was fulfilled: "the Word became flesh" (John 1:14).

In the next frame, Mary clasps the left hand of Elizabeth, whose right hand feels the baby leaping in her womb. Elizabeth exclaims with a loud voice, "Blessed are you among women, and blessed is the child you will bear! But why am I so favored, that the mother of my Lord should come to me? As soon as the sound of your greeting reached my ears, the baby in my womb leaped for joy. Blessed is she who has believed that the Lord would fulfill his promises to her!" (Luke 1:42–45).

A million repetitions of Hail Mary cannot turn Elizabeth's exuberant exclamation into a pious platitude. As "Holy Mary, Mother of God" stands there serenely receiving this greeting, I feel like the happy dog in the corner of the frame, bursting with the anticipation of hearing and seeing the fulfillment of Mary's Song (1:47–55).

Her song takes its name, the Magnificat, from the first line in the Latin version: *Magnificat anima mea Dominum* (literally, "Glorifies / my soul / the Lord"):

> "My soul glorifies the Lord
> and my spirit rejoices in God my Savior,
> for he has been mindful of the humble state of his servant.

celestial blue and gold beyond is the dawn of the kingdom of the One conceived in the Virgin's womb. God begins to rule on earth as in heaven by overshadowing Mary.

In the middle frame, Bruce dares to portray the event of the overshadowing: the conjunction of eternity and time, infinite divinity enclosed in one microscopic cell of humanity.

From now on all generations will call me blessed,
for the Mighty One has done great things for me—
holy is his name."

Mary knows more about the new life forming within her than any ultrasound or DNA test could tell her. She knows that God is giving her a son who will rule on David's throne and that his kingdom will never end. Though she is far from the center of power in Israel, and even farther from the center of power in the Roman Empire, she knows that her son will rule forever far above all earthly powers. All other kings and kingdoms will soon pass away, but her son's kingdom will never end. Gabriel's message confirms that God has chosen her to bring the Davidic king into the world through her womb, in fulfillment of the ancient promises of the Hebrew prophets. Her song expresses amazement that the Mighty One has done great things for her so that all generations will call her blessed. Then she moves beyond praising God for the great things he has done for her to praising God for his mighty works of mercy and justice for all:

"He has performed mighty deeds with his arm;
he has scattered those who are proud in their inmost
thoughts.
He has brought down rulers from their thrones
but has lifted up the humble.
He has filled the hungry with good things

but has sent the rich away empty.
He has helped his servant Israel,
remembering to be merciful
to Abraham and his descendants forever,
just as he promised our ancestors."

Mary is so confident that God's promises will be fulfilled through her son that all her verbs are in the present-perfect tense—justice has already arrived. God's mighty works have already swept Herod the Great and Caesar Augustus off the stage of history. Mary's son, Jesus, fills all her vision of the present and the future.

The Roman arches above Mary's head have almost vanished from sight. The gold of heaven above and the celestial blue of the future ahead break through and dominate Mary's world. The inauguration of God's kingdom on earth occurred when the power of the Most High overshadowed Mary and God's Son was conceived within her womb.

Bruce's painting *Miriam, Virgin Mother: Via Activa* (fig. 40) visualizes an upheaval of Mary's world and ours; it brings down the powers of the world and magnifies the glory of Mary's son. I am deeply disturbed by this painting and terribly delighted by it.

Bruce's art brings me down and lifts me up.

fig. 42. detail: central panel from *Magnificat—Second Adam* © 2007 Bruce Herman; oil with 23kt gold/silver leaf on wood, 125" × 144"

His end is the new beginning. The cross shatters the arch. The cross beheads the snake. The cross opens the way for the bright blue and resplendent gold of heaven to break through all earthly powers.

On the Second Adam Altarpiece

I found my response to Bruce Herman's *Second Adam: Via Contemplativa* (fig. 44) in a prayer of John Donne:

> Look Lord, and find both Adams met in me;
> As the first Adam's sweat surrounds my face,
> May the last Adam's blood my soul embrace.

I feel threatened by the first Adam. He looks like he is about to swing his arms from right to left and lunge forward. If he does, he will collide with me and knock me down. He's already in my space. I back away from the painting to avoid the collision. There's something terribly wrong with Adam. He is twisted, bent, and broken. Then, as I reflect, I remember that he is under the intolerable weight of a terrible curse (Gen. 3:17–19):

> Cursed is the ground because of you;
> through painful toil you will eat food from it
> all the days of your life.
> It will produce thorns and thistles for you,
> and you will eat the plants of the field.
> By the sweat of your brow
> you will eat your food
> until you return to the ground,
> since from it you were taken;

> for dust you are
> and to dust you will return.

The look in Adam's eyes and his posture express the despair of the Teacher who penned Ecclesiastes:

> What do mortals get from all the toil and strain with which they toil under the sun? For all their days are full of pain, and their work is a vexation; even at night their minds do not rest. This also is vanity. (2:22–23)

The red-brown, earthy color of the first Adam's body reminds me of my origin and my destiny. I am in Adam and Adam is in me. I too am twisted, bent, and broken. I am dust and to dust I shall return. Adam has in fact knocked me down.

The vine in Adam's hands leads my gaze upward to the Second Adam, who hangs on the cross. He appears to be near the end. His arms are so fully extended that they seem to be almost wrenched from their sockets. His head has dropped forward. His eyes are almost shut. His struggle to breathe is over. In his last gasp he declares his victory: "It is finished."

His end is the new beginning. The cross shatters the arch. The cross beheads the snake. The cross opens the way for the bright blue and resplendent gold of heaven to break through all earthly

fig. 43. Penultimate state of *Second Adam* ca. 2006, showing donor portraits, additional figures—all scraped or over-painted early 2007

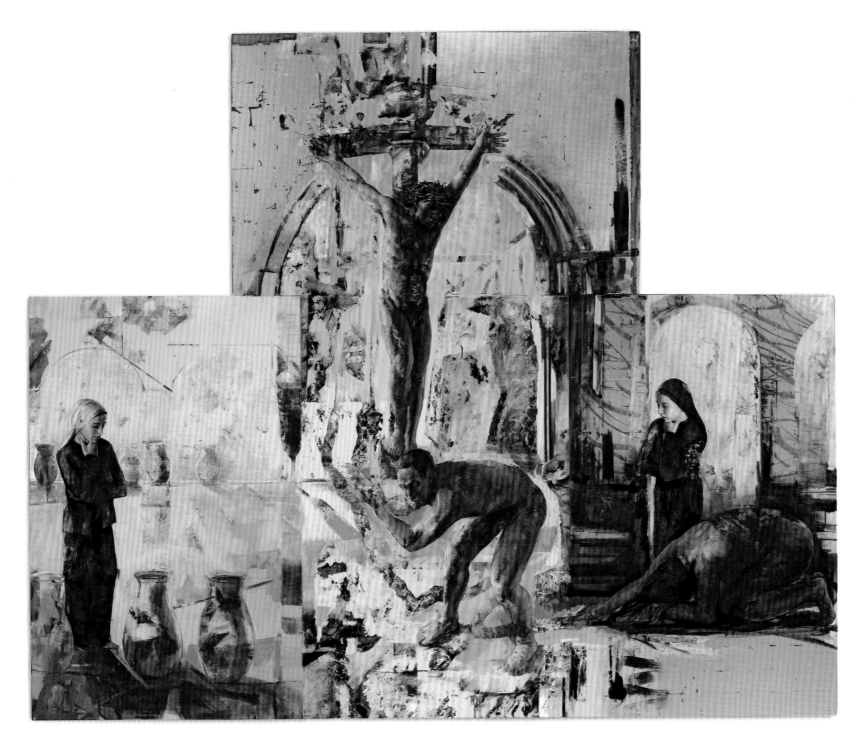

fig. 44. Final state: *Second Adam* © 2007 Bruce Herman; oil with 23kt gold and silver leaf on wood, 125" × 144"

powers. No oppressive tyranny can stop the power of the cross of Christ. "The Light shines in the darkness, and the darkness has not overcome it" (John 1:5).

Jesus' broken body is the Bread of Life from heaven. When I look again at the body of Christ on the cross (fig. 42), it looks like Bruce has portrayed Christ at the nadir of his descent from heaven.

The apostle Paul's hymn to Christ tells the story of the long descent of Christ (Phil. 2:6–8):

> Who, being in very nature God,
> did not consider equality with God something to be used
> to his own advantage;
> rather, he made himself nothing
> by taking the very nature of a servant,
> being made in human likeness.
> And being found in appearance as a man,
> he humbled himself
> by becoming obedient to death—even death on a cross!

The Bread of Life from heaven is the Almighty God who emptied himself and humbled himself to die on a cross.

There hangs God crucified.

The Second Adam suffered the death of the first Adam, so that as "in Adam all died, in Christ will be made alive" (1 Cor. 15:22). I stand before this painting and know that I am dying by union with the first Adam but am being made alive by union with the Second Adam. "I have been crucified with Christ and I no longer live, but Christ lives in me. The life I now live in body, I live by faith in the Son of God, who loved me and gave himself for me" (Gal. 2:20).

Now my attention moves to Mary on the left side of the cross, as she looks toward the cross in the future. She stands in an enclosed garden with large water jars. She is pondering what has just happened there. Near the end of a wedding ceremony in Cana, she'd noticed that there was no more wine and told her son. He responded that his hour had not yet come. Nevertheless, knowing Jesus as well as she did, she asked the servants to do whatever he told them. He told them to fill with water the jars used for ceremonial cleansing. After they did so, he told them to draw some out and take it to the master of the banquet. When the master tasted it, he was astonished. "Why have you saved the best wine until the end of the ceremony?" he wondered.

Now Mary wonders. She knows that the life has gone out of the party. The marriage ceremony is on the brink of collapse. Only her son's intervention will save the couple from disgrace. By his miraculous power, he not only revives the ceremony but also fills everyone with a joyful exuberance they have never experienced before. Mary knows this is a sign of something much greater than the restoration of one marriage ceremony in Cana. What about the restoration of God's marriage with Israel, his bride? That relationship is obviously on the brink of collapse. Despite all the elaborate ceremonial cleansing, a pervasive dullness of heart remains. All the whitewashing on the outside cannot hide the deadness within.

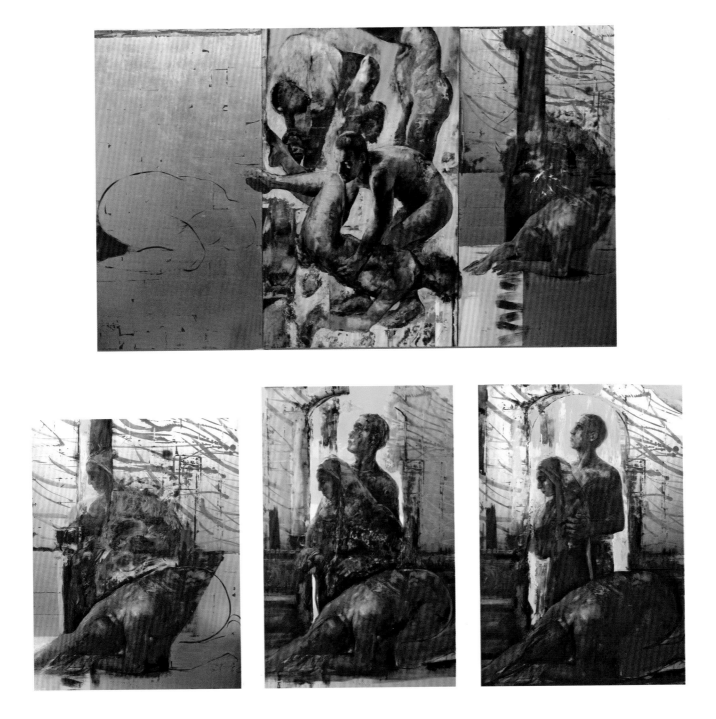

fig. 45. Top: earliest state of *Second Adam* (2005)

fig. 46. Bottom: Successive stages of right-hand panel with figures of Eve (foreground), Mary, and John (over-painted)

What does it mean that Jesus' hour had not yet come? How will his hour revive God's marriage with Israel? Mary remembers the words of the prophet Simeon at the dedication of her son in the temple (Luke 2:34–35):

> "This child is destined to cause the falling and rising of many in Israel, and to be a sign that will be spoken against, so that the thoughts of many hearts will be revealed. And a sword will pierce your own soul too. "

There in the garden she ponders what pain her son and she will suffer when his hour comes. She knows that the way for her son to fulfill his destiny—"to cause the falling and rising of many in Israel"—will be the way of suffering. We know, as we look at her deep in thought in the garden, that the way of suffering is the suffering of the cross. By his own falling and rising, Jesus embodies the history and future of Israel.

Now my attention turns to Mary on the right side of the cross. as she looks back on the cross in the past. Certainly a sword pierced her own soul as she watched her beloved son dying the most horrifying, shameful death. A late thirteenth-century hymn, "Stabat Mater Dolorosa," meditates on Mary's pain at the foot of the cross:

> The sorrowing mother stood
> weeping by the cross
> while her Son hung there.
> Her grieving soul
> sad and sorrowing
> was pierced by a sword.

As Mary remembers and ponders that day of unbearable grief, she realizes now that her son had to be nailed to the cross for her to be set free, he had to be torn for her to be mended, he had to die for her to be born anew. She stands there as the new Eve of the new humanity, redeemed from death by her son's death. Below her lies the broken, grieving, dying first Eve of the old humanity.

In contrasting the two Adams and two Eves, Bruce's painting visually proclaims the gospel: the cross of Christ is God's way to take the suffering of the fallen human race into himself. The cross of Christ is the beginning of the new humanity in Christ.

As I look at this painting, I want to say to every son and daughter of Adam and Eve bent over in despair and prostrate with grief, "Look up! Look to Christ there on the cross! Look and live!"

fig. 47. final state of *Mater Dolorosa* from right hand panel of *Second Adam* (fig. 46)

Magnificat

B. Herman

In this series of paintings—a triptych and a large multipanel altarpiece conceived for a monastery in Orvieto, Italy—I attempted both to paint out of a great tradition and to contribute something fresh to the *sacra conversazione* of art that speaks about Mary, the mother of Jesus Christ. This was a challenging project that took everything of which I am capable as an artist and man of faith.

The first problem for me was that I had no sense of who the Virgin Mary really was or is—my Protestant upbringing never mentioned her except in passing once a year, during the usual recitation of the Christmas story. In fact, the absence of any talk or meditation on her or her role in the Gospel story now seems to me very strange indeed. The antipathy toward her story and person among evangelical Christians has only become more and more perplexing to me in the wake of this project.

Who was this young woman? Why did the chief among archangels address her as "highly favored of God," and what did that greeting mean? (Mary herself asks this question!) Why is there so little about her in the Bible, aside from a few scattered verses? And lastly, why has she assumed such stature (*Theotokos*/God-bearer) in the Roman and Eastern traditions, and why has her story been so neglected in the Protestant church as to be a side matter?

As an artist attempting to evoke some sense of who she was (and is) and to communicate something fresh about motherhood and the sacredness of it, I had my work cut out for me—being schooled in a tradition that avoids the thought of Mary or motherhood having anything other than a functional role in our spiritual life.

As I sketched and ruminated about Mary, the very first image that "came" to me was from Luke's nativity story, wherein the angel Gabriel speaks:

fig. 48. detail: *Called* (study for Mary in *Magnificat*) © 2006 Bruce Herman; oil on wood, 65" × 48" ; collection of Bjorn and Barbara Iwarsson

> I attempted both to paint out of a great tradition and to contribute something fresh to the *sacra conversazione* of art that speaks about Mary, the mother of Jesus Christ.

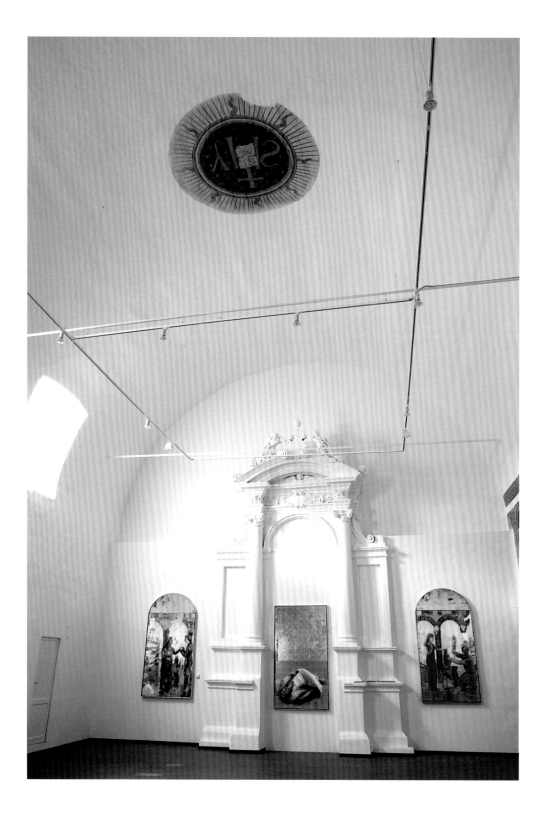

Gold, the one elemental metal that is utterly stable—changeless and pure— a fitting image of God's Holy Spirit suffusing the young woman entirely.

fig. 49. Installation view of *Magnificat* triptych at Monastero San Paolo, a 13th-century Benedictine convent in Orvieto, Italy

"The Holy Spirit will come upon you, and the power of the Most High will overshadow you; therefore the child to be born will be called holy—the Son of God" (Luke 1: 35, ESV).

The archangel's explanation of the divine conception is a mystery that I have never really seen depicted, except as a very thin golden thread issuing from a dove aimed toward the Virgin's womb (Italian school) or as a mysterious ray from the sky (Byzantine icon tradition). I have never felt that these images convey the sense from the rather laconic text in Luke. The archangel speaks of the "overshadowing" of the Virgin—yet Scripture speaks of God as light and as having no shadow, no darkness at all. How can light overshadow a woman? In my reflections the image came to me as a complete painting (fig. 40): Mary crumpled on the floor, surrounded entirely by gold—and not just gold, but enveloping gold, overwhelming gold. Gold, the one elemental metal that is utterly stable—changeless and pure—a fitting image of God's Holy Spirit suffusing the young woman entirely.

This painting was a gift, but not one that came free of charge in terms of the painting process. I literally had to un-paint the first version on the large wood panel covered with gold leaf. The first version, and several versions of Mary's face, had to be scoured off the surface and repainted in order to achieve the right balance of intense emotion, movement, and calm contemplation—a series of paradoxical qualities. It is rare, in my experience, for an image to come to me fully developed, requiring only that I faithfully execute and "get it right."

In utter contrast to the experience of making *Overshadowed*, I vigorously lost and found and lost again the image that

eventually became *Second Adam* (see fig. 43 and fig. 44). This large multipanel altarpiece, like the *Magnificat* triptych, was part of a search for images that would adorn the chapel of Monastero di San Paolo, a thirteenth-century Benedictine monastery in Orvieto. I began the painting as four separate panels while teaching a course in Orvieto in 2003 for the Gordon College Italy program (then housed at Monastero di San Lodovico). I employed eighteen students as apprentices to begin the paintings, having them assist in everything from research on Marian legend to practical studio techniques like applying the many layers of traditional gesso (marble dust and hide glue) to the large wooden panels, sanding and re-sanding to achieve the perfect surface for gilding.

I taught several of the students how to do the gilding: apply the gold and silver leaves in a highly delicate process that is a little like holding your breath and placing a microscopic object on a laboratory slide. The gold or silver, being only microns thick, literally crumples and blows away, useless, if the artist fails to handle it properly. The students were diligent and enthusiastic and enjoyed the apprentice work, but they never managed to actually assist in the painting. Our month together flew by as we began the preparatory stages of the altarpiece.

Two years later, in June 2005, I returned to Italy for my exhibit, *Il Corpo Spezzato (The Body Broken)*, at Museo Palazzo dei Sette, and to continue work on the altarpiece. At that time I began to realize that I would need to ship the panels Stateside if I were ever to finish them. I met with Walter and Darlene Hansen at the exhibition in Orvieto, and we began what has become a close friendship and collaboration on these and other painting projects. Darlene and her friend Denise Adams attended my artist-residency at the museum (Studio Aperto) every day for

a week, and both families contributed to the shipping and completion of the panels here in Gloucester, Massachusetts, where I live and work. (The same families later provided funding for an international exhibition tour of the paintings, which continues in the United States as of this writing.)

The large altarpiece *Second Adam* was conceived in many stages and underwent massive revisions over a period of more than 40 months (see figs. 43–47 for a visual record of this process). During that time the piece went from being a series of single panels in a row, to a triptych, to a polyptych, and finally to a large single image consisting of four interlocking panels that were salvaged from the "wreckage" of the other versions—all from a sequence on the life of the Virgin Mary and her son Jesus Christ. During the many months I worked on this piece, it seemed to change and shift under my very hands—both physically and symbolically. Daily, it seemed, I would paint in aspects of the image, only to return to the studio the next day to find the image "stale" or unconvincing. For months and months on end I struggled with the painting, thinking and feeling that I must find a way to show Mary as the strong yet contemplative woman she undoubtedly was.

One of the only personal qualities we hear about Mary is from Luke 2:19: "But Mary treasured up these things and pondered them in her heart." In other words, we hear that she was a thinker, someone given to pondering and internalizing the angelic message. Perhaps that is why she was chosen to bear the Christ child—because she possessed an inner strength of character and a deep commitment to a life of prayer and meditation as well as nurture and motherhood. In the painting

Second Adam she becomes the implicit "second Eve" who (unlike the first Eve) is obedient to the word of God given her by the archangel: "I am the Lord's servant. May your word to me be fulfilled." And unlike the first Adam, who disobeyed God and then blamed God and his own wife ("the woman you put here with me—she gave me some fruit from the tree, and I ate it"), the "Second Adam," Jesus, is obedient like his mother ("obedient to death—even death on a cross"), even taking all the blame for all sin upon himself ("God made him who had no sin to be sin for us").

Thus the imagery in the altarpiece is all about second chances—the possibility of genuine hope after our downfall, a hope that is secured by grace and love, not a perfectly kept record of righteous deeds on our part.

In the central part of the image, the crucifixion, the large cross bends under the weight of universal sorrow and sin, becoming a golden (or bronze) snake at the very top of the painting. Christ is crucified on the very tree that caused the downfall of the human race, the very pole that held the bronze snake aloft as God through Moses miraculously rescued the Israelites from the plague of venomous snakes and certain death (see Num. 21:4–9).

The Tree of Death becomes the Tree of Life, and the long, oversized vine that Adam holds in the foreground of the painting wraps around and finally fuses with that tree. The very instrument of torture and death becomes the means of liberation and life—a vine whose branches we are to become as Christ's fruitful disciples (John 15).

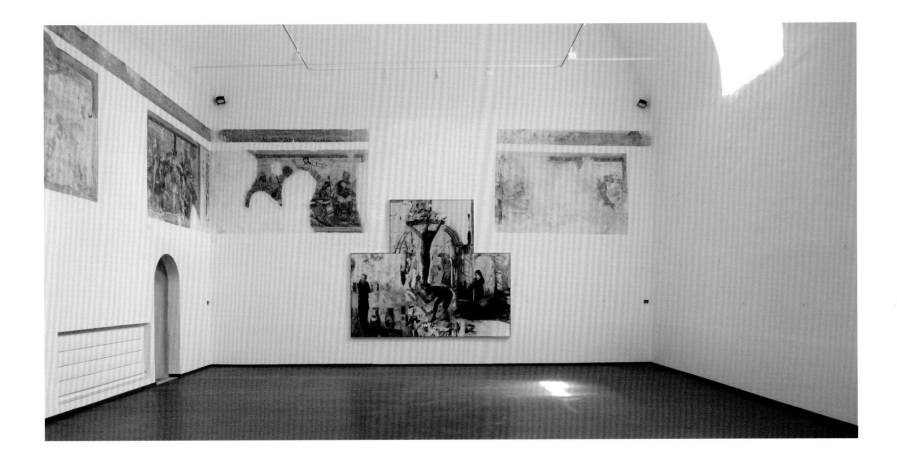

fig. 50. Installation view of *Second Adam* in Monastero San Paolo, Orvieto, Italy

Presence/Absence

fig. 51. detail: *Prospero's Tempest* (from *Presence/Absence*) © 2007 Bruce Herman; oil and alkyd resin with silver leaf on wood panel, 72" × 60"

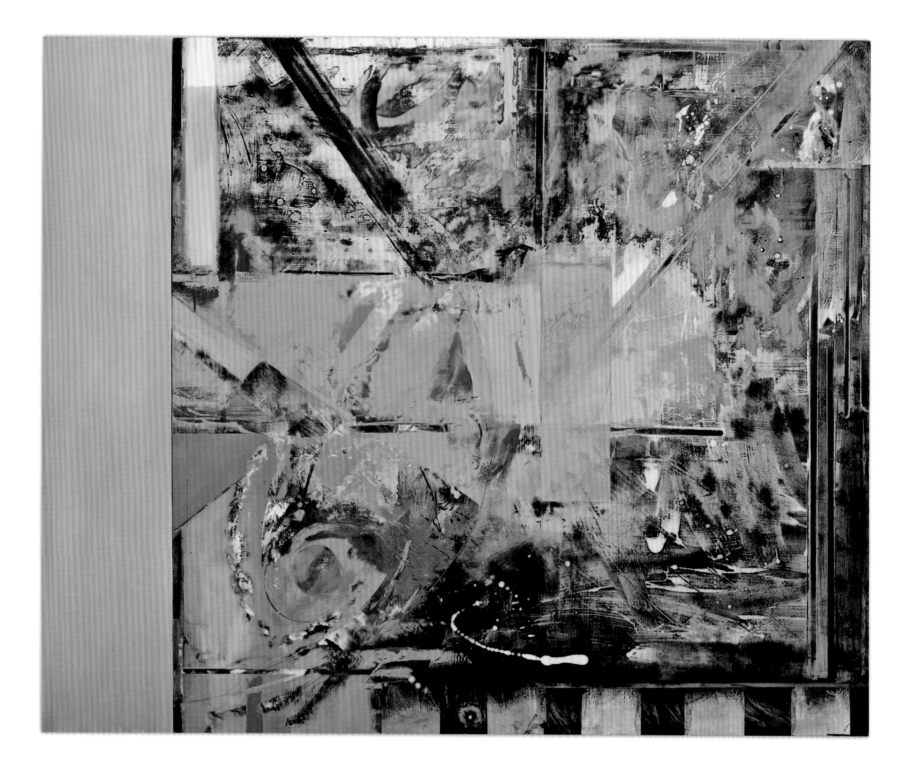

Chapter 10

Presence/Absence

SW Hansen

I follow Bruce on a black muddy trail under a thick canopy of early spring oak leaves still dripping from last night's thunderstorm. He points to blankets of gray-green lichen on granite boulders and to golden rays of sunlight illuminating pools of silver rainwater in shallow basins. After I stop for a moment to catch my breath and lean against an oak tree, my hand bears the imprint of corrugated bark. I breathe in the pungent fragrance of the wet forest bed, of last year's leaves, decaying logs, and rich soil. We hear a melodious bird song, and Bruce guides me to see a rose-breasted grosbeak.

"That's a rare sighting in our woods," he says. As I employ all my senses to take in the forms, colors, sounds, songs, and textures of the woods by the Great Ledge of Cape Ann, I begin to love Bruce's garden home.

I think of William Wordsworth's prophets of nature:

> Prophets of nature, we to them will speak
> A lasting inspiration, sanctified
> By reason, blest by faith: what we have loved
> Others will love, and we will show them how.

Bruce, a prophet of Cape Ann, shows me the world he loves in his painting series *Presence/Absence*. His generous use of gold and silver leaf in these paintings makes me think that he sees heaven on earth in this place. The colors of dirt and flora overlap and cohere with the colors of stars; spirals in the dust trace spirals of galaxies. Will Bruce's paintings lead me down a path to a hidden gate into some other celestial place? I feel that if I look long enough at *Presence/Absence*, I will fall into

I feel that if I look long enough at *Presence/Absence*, I will fall into a magical world just as Lucy, Edmund, and Eustace fell into Narnia after looking at the picture of the Narnian ship.

fig. 52. *Prospero's Tempest* (from *Presence/Absence*) © 2007 Bruce Herman; oil and alkyd resin with silver leaf on wood panel, 72" × 60"

fig. 53. *Walking the Great Ledge* series *(Spring and Summer)* © 2010 Bruce Herman; oils, silver, gold leaf on wood; each 60" × 40"; collection of Cape Ann Museum

Walking the Great Ledge series (Autumn and Winter)

a magical world just as Lucy, Edmund, and Eustace fell into Narnia after looking at the picture of the Narnian ship. I do not try to explain these paintings any more than I would try to explain the song of the rose-breasted grosbeak. I simply enter into them and go through them into another world.

Bruce lures me into his world by painting diaphanous fields of cobalt, turquoise, cerulean, and gray-green. I float peacefully, completely at ease in these panels. They give me contemplative places to clear my mind. They offer a respite from the complexity in the adjoining panels.

Walking the Great Ledge

Walking the Great Ledge with Bruce, I observe multilayers of life and death: newborn trees rising out of logs decomposing into the ground covered by a carpet of Canada mayflowers with tender green shoots and delicate white flowers—a fresh, exuberant beginning; a slow, inexorable ending; and everything in-between. And below this cycle of life, I see the exposed bedrock of Cape Ann granite. This granite dates back to the Silurian age, about four hundred million years ago. Around one million years ago, the entire continent began experiencing regular ice ages. The Laurentide ice sheet, during the Illinoian period, covered the entire state of Massachusetts in thousands of feet of ice. The advance and retreat of immense glaciers

carved the topography of Cape Ann. Melting ice released vast amounts of water, shaping and throwing the massive boulders I see on our walk. Twenty-two thousand years ago, New England was covered in ice. The Great Ledge and Walker Creek owe their characteristic contours to the destructive/creative force of freezing and melting water. And since the ice ages, water continued to form Cape Ann. Regular tides and dramatic weather patterns constantly contribute to the cape's shape.

Bruce portrays the four seasons and geological ages on Cape Ann by his process of painting, scraping, painting, sanding, and painting again. The complex layers created by the advance of the painter and the retreat of the sander reflect the topography shaped by the advance and retreat of glaciers and tides. The texture of the paintings points to the presence of creative and destructive forces at work shaping landscapes to bear the light of the springtime and the weight of the Silurian age.

The edge of the painting *Prospero's Tempest* (fig. 52), resembling the alternating light and dark marble face of the Cathedral of Orvieto in Italy, hints that these landscapes are sacred spaces for Bruce. During his years of creative work and teaching in Orvieto, Bruce often found peace, renewal, and communion with God in that cathedral. While walking the Great Ledge on Cape Ann, he points with awe and delight at the wonders of his garden sanctuary: immense walls of dark-brown oak intermixed

with silver-white birch, granite floors covered in gray-green lichen, and a high cathedral ceiling of sky blue behind celadon leaves. This is a place to be quiet and to listen for another Voice.

Bruce's love for his cathedral on the cape leads him to speak passionately about caring, as wise stewards, for the whole of Creation. He talks of being involved as an artist in a grand reclamation project that turns us from greedy abuse of Creation to a tender love for our beautiful blue-green garden home. We have the capacity and the choice to be either destroyers or gardeners. The geometrized abstract shapes in his paintings, especially in the *Walking the Great Ledge* series (fig. 53) depicting the four seasons, show me the work of a wise gardener, shaping and arranging the elements as a collaborator with God in the process of creation.

I am bewildered by the literary allusions in the titles of some paintings: *Prospero's Tempest*, *Prospero's Staff* (fig. 57), *Little Gidding*, *Unremembered Gate*, *The Fire and the Rose Are One*. What do these paintings have to do with a Shakespeare play and T. S. Eliot's poems? I wonder. I am curious to know what Bruce was reading and thinking when he did these paintings. Are there any observable connections between these paintings and literature? Not so far as I can see, at least not at first or even second glance. I am reminded of standing for a long time in the Museum of Modern Art, in front of the color field painting by Barnett Newman titled *Abraham*, and wondering how the stripes of black and gray related to the biblical character. Even though I never saw a direct connection, Newman (1905–1970) led me to meditate on the Abraham narrative as I absorbed his painting. Perhaps that is Bruce's intent: he wants me to contemplate *The*

Tempest and *Four Quartets* as I look at his art because that is what he did when he created it.

Shakespeare's *Tempest* is a parable of the power of art. When Prospero's daughter sees that the destructive tempest was art produced by Prospero to take revenge on his enemies, she pleads with him: "If by your art, my dearest father, you have / Put the wild waters in this roar, allay them."

Finally, Prospero decides to offer mercy rather than seek revenge, and he relinquishes the powers of his art:

> Have I given fire, and rifted Jove's stout oak
> With his own bolt; the strong bas'd promontory
> Have I made shake and by the spurs pluck'd up
> The pine and cedar. Graves at my command
> Have waked their sleepers, op'd and let 'em forth
> By my potent art. But this rough magic
> I here abjure, and when I have requir'd which even now
> I do,
> Some heavenly music to work mine end upon their
> senses, that
> This airy charm is for, I'll break my staff,
> Bury it fathoms in the earth
> And deeper than ever plummet sound
> I'll drown my book.

Prospero's Tempest

In *Prospero's Tempest* (fig. 52) I see a black staff raised above a raging storm below: a wild, swirling, cyclonic wind, a blur of

fig. 54. *Little Gidding* © 2010 Bruce Herman; oil on wood; 60" × 70"

rain and mist, topography ravaged by the deluge. (Ah, Bruce, if by the powers of your art, you have wreaked such havoc, have mercy!) Yet I see in this painting that the marbled cathedral holds fast even in the worst tempest. Though the seas roar and the mountains shake, we stand on a solid rock.

As if to show us the way of mercy, not revenge, *Prospero's Staff* (fig. 57) displays a white staff broken in pieces. Except for a few drops, reminders of yesterday's storm, stillness fills the air. Long, smooth, sweeping brushstrokes calm the land. Now is the time for mending the torn and healing the wounded.

Little Gidding

We come to the still point in the painting *Little Gidding* (fig. 54). In this piece Bruce's love for his garden home merges with T. S. Eliot's *Four Quartets* to give birth to his most radiant painting: the sun flames the canvas, a brilliant visual for Eliot's lines in "Little Gidding":

> The brief sun flames the ice, on pond and ditches,
> In windless cold that is the heart's heat,
> Reflecting in a watery mirror
> A glare that is blindness in the early afternoon.
> And glow more intense than blaze of branch, or brazier,

> Stirs the dumb spirit: no wind, but pentecostal fire
> In the dark time of the year.

I imagine that the sun also strangely warmed Bruce's heart on a cold midwinter afternoon by the Great Ledge so much that he used up all his sunshine yellow on this canvas to convey his own brush with Pentecostal fire. The burst of sunlight in the lower-left corner of the painting sends its tongues into every place inside and outside the painting. No heart is safe from its flames.

T. S. Eliot's pilgrimage to the church at Little Gidding in May 1936 gave him the name and story for his fourth quartet. He even gives us directions for our pilgrimage to this sacred place:

> If you came by day not knowing what you came for,
> It would be the same, when you leave the rough road
> And turn behind the pig-sty to the dull facade
> And the tombstone.

The English scholar and ordained deacon Nicholas Ferrar, whose tombstone stands in the pathway leading to the small church, brought his family to this site in 1626 to establish a community devoted to a daily regimen of prayer guided by the *Book of Common Prayer*. Ferrar's words are engraved in the stone lintel over the entrance to the church: "This is none other but the

house of God and the gate of heaven." Eliot brings us to this sacred spot to pray:

> If you came this way,
> Taking any route, starting from anywhere,
> At any time or at any season,
> It would always be the same: you would have to put off
> Sense and notion.
> You are not here to verify,
> Instruct yourself, or inform curiosity
> Or carry report.
> You are here to kneel
> Where prayer has been valid.

The Great Ledge

In *The Great Ledge*, Bruce brings us to his own Little Gidding, a sacred place to kneel where prayer has been valid. Here at the Great Ledge, on Cape Ann (Bruce's neighborhood) as at Little Gidding (a small village near Cambridge), there is also "the intersection of the timeless moment" when one moves from the here and now into the house of God through the gate of heaven.

Valid prayer comes through death: "communication / Of the dead is tongued with fire." Fire burns all to ash, "the ash the burnt roses leave." And . . .

> The only hope, or else despair
> Lies in the choice of pyre or pyre—
> To be redeemed from fire by fire.

We are invited to choose the fire of purifying love as the way of redemption from the fire of passion and anger:

> Love is the unfamiliar Name
> Behind the hands that wove
> The intolerable shirt of flame
> Which human power cannot remove.
> We only live, only suspire
> Consumed by either fire or fire.

We will be consumed either by the infernal fire of self-love or by the eternal fire of compassionate love. The fire that redeems is the Pentecostal fire:

> The dove descending breaks the air
> With flame of incandescent terror
> Of which the tongues declare
> The one discharge from sin and error.

The Spirit descending leads the way to freedom from earthly powers into divine relationships. So Eliot ends "Little Gidding" with an urgent invitation:

fig. 55. *The Great Ledge* © 2007 Bruce Herman; oil and 23kt gold leaf on board; 23" × 14"

Quick now, here, now, always—
A condition of complete simplicity
(Costing not less than everything)
And all shall be well and
All manner of thing shall be well
When the tongues of flame are in-folded
Into the crowned knot of fire
And the fire and the rose are one.

When the earthly beauty of the rose converges with heavenly redemptive fire, then all shall be well. Through the fire of love empowered by the Spirit, temporal beauty is transformed through death into eternal life.

I come again with these lines to Bruce's painting *Little Gidding* and find that the burst of flames radiating throughout the canvas is intermingled with the dust of death and the ash of burnt roses all encompassed in the cathedral of the Great Ledge.

Bruce paints a *Witness* (fig. 56). The earthly substance of the Great Ledge fills every cell of his body. From the dust of this ground, the artist forms him and breathes into him the breath of life. *Witness* shows us the way to the unremembered gate and leads us into the Eden of Cape Ann.

There we feel a real Presence.

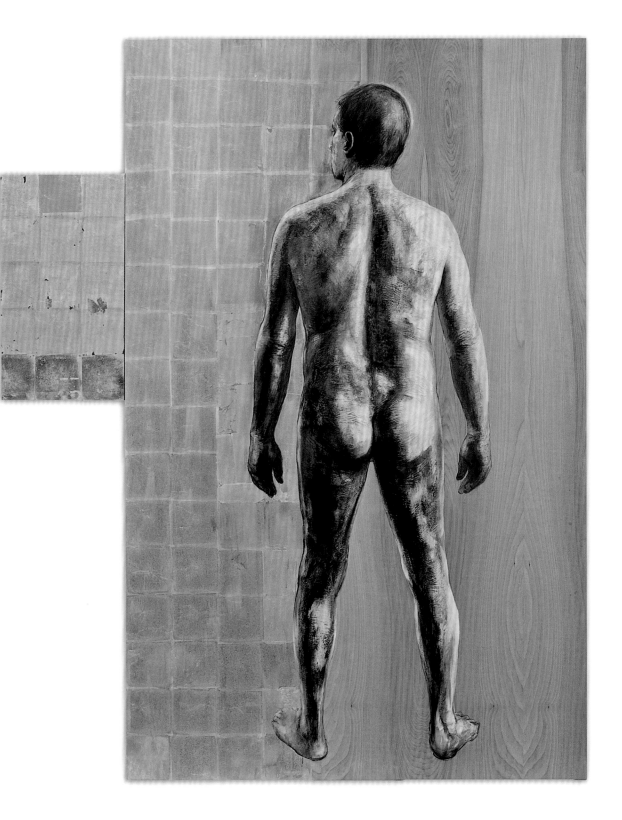

fig. 56. *Witness* © 2010 Bruce Herman;
oil and silver leaf on wood; 78" × 63"

Presence/Absence

B. Herman

As I write, the season change here in New England is making itself known on multiple levels. The recent storms and the precipitous temperature drop over the past two weeks have denuded the trees of most of their colorful leaves (which lie strewn over everything like an extravagant, continuous collage of crazy shapes and color). The air begins to take on that familiar scent of rotting leaves—an altogether pleasant thing—redolent of happy childhood memories and that musty, earthy quality that simultaneously reminds one of the inevitability of decay and also makes for a very particular, poignant enjoyment. A mixture of sight, smell, and deep associations with particular places and times marks my most vital visual memories—and memory is where I begin this entry about the painting series *Presence/Absence*.

Most of my work as an artist has been drawn from memory and imagination as much as it has from observation and careful attention to the physical world. I suppose I could say that I am the kind of artist who draws from the inside as much or more than I do from the external world of nature. When the famous abstractionist Jackson Pollock was asked by fellow artist Hans Hoffman if he worked from nature (in reference to his baffling drip paintings), Pollock answered somewhat elliptically, "I am nature."

And by this he meant what I am trying express: that some artists, rather than simply rendering pictures of the visible world with accuracy, draw upon tendencies that are deeply embedded in their nature, their inmost self—which is indeed part of nature and which can express the patterns and qualities of nature without resorting to traditional depictions of landscape. Think for a moment of the seemingly random way pine needles fall in the forest, or the way moss and lichen grow on rocks, or the veining of marble or the millions of flecks of mica in a piece of granite. The pattern is imperceptible but real—and nature seems almost as inclined to indulge in hidden or random patterning as in obvious shapes like a maple leaf or the more predictable quasi-geometric facets of a crystal.

And Pollock's drip paintings participate in the more "random" patterning that nature produces in great amounts. I mention Pollock and his work at some length because, for me, the inner patterning and the pre-verbal, pre-conceptual aspects of form are often the most absorbing as I try to make sense of both my

fig. 57. *Prospero's Staff* © 2009 Bruce Herman; oil and silver leaf on wood; 60" × 70"

fig. 58. Gallery installation views of *Presence/Absence* at Cape Ann Museum, Gloucester, Massachusetts
all works © 2009 Bruce Herman; mixed media with silver and gold leaf on thirty-five separate wood panels

inner and outer world—both of which are included in nature. As Pollock said, we are nature.

When I began the *Presence/Absence* suite, I was steadily working away at the large altarpieces that have come to be collectively titled *Magnificat* (pp. 71–75). I would spend long days working at a particular figure or passage on one or the other of the many panels the project comprises—one in which I've attempted to invoke the contemplative life of the Virgin Mary. During those many months—years, really—I would sometimes break free entirely of the constraints of that particular narrative and its demanding technical labor, and I would play at random abstraction in smaller, less ambitious paintings as a sort of sideline. At one point I had at least two-dozen smaller works in various states of completion, all of them completely abstract and unrelated in any overt way to the project at hand. (Yet later the backgrounds of the Mary paintings came to look just like those seemingly random abstract paintings.)

Call it diversion or an attempt to escape from the high demands of making a large figurative/narrative altarpiece, but these many playful abstract paintings became a means of working through a multitude of formal and even spiritual logjams that I found myself perpetually experiencing in the years 2006 through 2008, as I finished the Mary paintings. As you can see in the installation views of these abstract meditations on the landscape (pp. 92–93), Cape Ann became a kind of horizontal band-

background for the figure in *Witness* (fig. 56). The exhibition installation toured to five museums across the United States in 2010–2011.

Like drip painting was for Jackson Pollock, this abstract series became for me a chance to break out of the confines of illusionistic rendering (and that is what "realistic" painting is in actuality: illusionism, where the marks of paint on a flat surface are meant to be read as a three-dimensional illusion of specific objects and spaces in the "real" world).

In a way, *Presence/Absence* is the most "realistic" painting I have ever done. And by realistic, I mean simply the literal fact of paint on the surface of the panel or canvas—with no attempt to depict or create a convincing illusion of some external object like a cloud, or face, or another of the millions of discrete objects filling our lives. This suite of paintings comes closest to being the simple fact of paint on a surface of anything I've ever made. And it is precisely this literalism that freed me to play, to investigate afresh the act of painting as a means of achieving some "objective correlative" (to use T. S. Eliot's famous phrase) for the real world—the world of Cape Ann—my home of four decades.

Cape Ann, a peninsula north of Boston, was first settled by the Pilgrims in the 1620s, becoming a thriving fishing port over the course of the first century of its habitation by European immigrants. It has a unique geological origin, being a glacial

I wanted to be freed from the requirements of producing a convincing illusion of this place on a flat canvas. Instead, I sought a fitting equivalence in which the thickness or thinness of the paint, the brush mark or scraping, became a stand-in for the granite or the foliage, the grasses or the lichen.

moraine filled with huge granite ledges erupting out of the soil, as well as with large free-standing boulders—some the size of a large house. Gloucester, Massachusetts, is one of four towns on the cape, and it has been my home as well as the site of my maturation as a painter. I find the textures and colors and shapes of this place penetrating into all those abstract explorations I did during the time I was so focused on completing the *Magnificat* altarpieces.

In particular, I have been fascinated by the growth of lichen on the granite ledges on our property—as well as by the powerful sense of geological time, glacial time, that pervades this part of the cape. If you walk to the back of our land, you will come to a formation of ledges called the Great Ledge—a palisade that borders the salt marshes along Walker Creek. It is a marvelous vantage point for glimpsing the ocean in the distance, as well as the tidal estuary 70 feet below. My many years living here have provided me with plenty of internalized memories of these forms—both the forms in flux (the seasonal and tidal changes) and those that seem immovable and permanent: the ledges and the ancient moraine.

Looking at the *Presence/Absence* paintings, a viewer might first notice certain characteristic textures. You could easily identify a corollary between the brush marks in oil paint and some of the

"random" patterns mentioned above. You might also see, in these compositions, echoes of certain colors and shapes commonplace here on the cape: the particular gray-green of lichens; the brine-green of the tidal estuary and its grasses; the overarching blue of the sky and sea; and the lush reds, oranges, and umbers of the New England foliage in autumn. Yet all of this landscape is steeped in the juices of memory and imagination. None of it is straightforward reportage, and that is intentional. I wanted to be freed from the requirements of producing a convincing illusion of this place on a flat canvas. Instead, I sought a fitting equivalence in which the thickness or thinness of the paint, the brush mark or scraping, became a stand-in for the granite or the foliage, the grasses or the lichen.

Through the paint, the brushstrokes, the scraping and sanding and re-working of textures and compositional elements, I was attempting to discover a means of evoking some of the internal echoes of a strong sense of place. I wanted the sum total to have the "feel" of Cape Ann rather than being a mere copy of its appearances.

T. S. Eliot's years of experience here on Cape Ann yielded a wonderful poem (part of *Four Quartets*) titled "The Dry Salvages"—referring to a rock formation just off the coast that

often captured the flotsam and jetsam of wrecked ships, lobster pots and buoys, bits and pieces of storm-torn docks.

In "The Dry Salvages" Eliot attempts to evoke the passage of time marked only by the ocean's movement and its impassive voice, which ignores our plight:

> The river is within us, the sea is all about us;
> The sea is the land's edge also, the granite
> Into which it reaches, the beaches where it tosses
> Its hints of earlier and other creation:
> The starfish, the horseshoe crab, the whale's backbone;
> The pools where it offers to our curiosity
> The more delicate algae and the sea anemone.
> It tosses up our losses, the torn seine,
> The shattered lobsterpot, the broken oar
> And the gear of foreign dead men.
> The sea has many voices,
> Many gods and many voices.
> ("The Dry Salvages," 1.15–26)

Eliot captures my own persistent sense of the ocean and the tidal estuary as a time-keeper in *Time and Tide at Walker Creek* (fig. 59), albeit one that is part of something so large we cannot make out its pattern (apart from the regularity of tides and the waves and their etching in the sand). Again, that larger, imperceptible pattern is what I've attempted to get at in these paintings—and it may be impossible to achieve. Yet the attempt is everything. God's beauty is known only in the reaching for deeper receptivity to God's ways, God's own design. Again, as Walter has previously quoted from "Little Gidding":

> . . . You are not here to verify,
> Instruct yourself, or inform curiosity
> Or carry report. You are here to kneel
> Where prayer has been valid. And prayer is more
> Than an order of words, the conscious occupation
> Of the praying mind, or the sound of the voice praying.
> ("Little Gidding" 1.45–52)

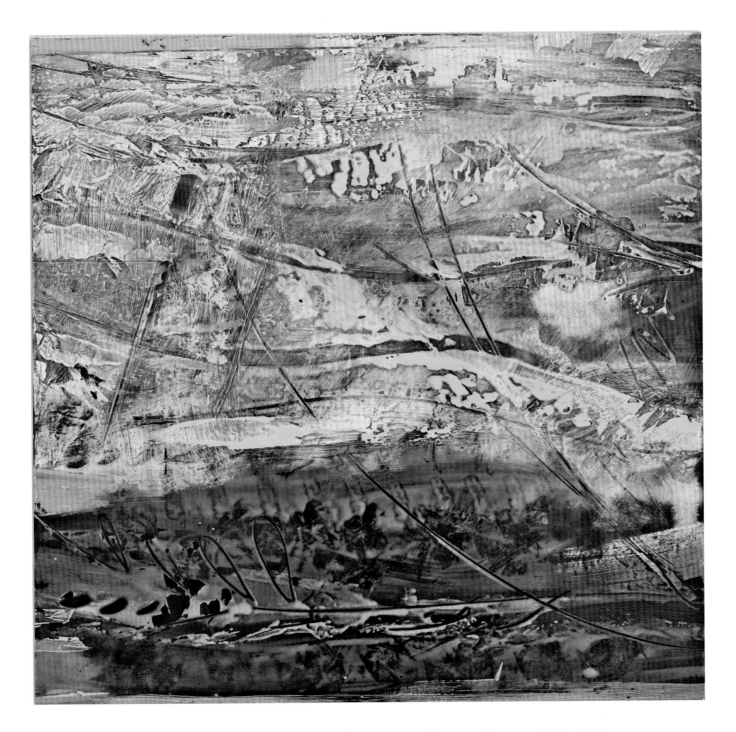

fig. 59. *Time and Tide at Walker Creek* © 2009 Bruce Herman; oil on wood; 23" × 23"

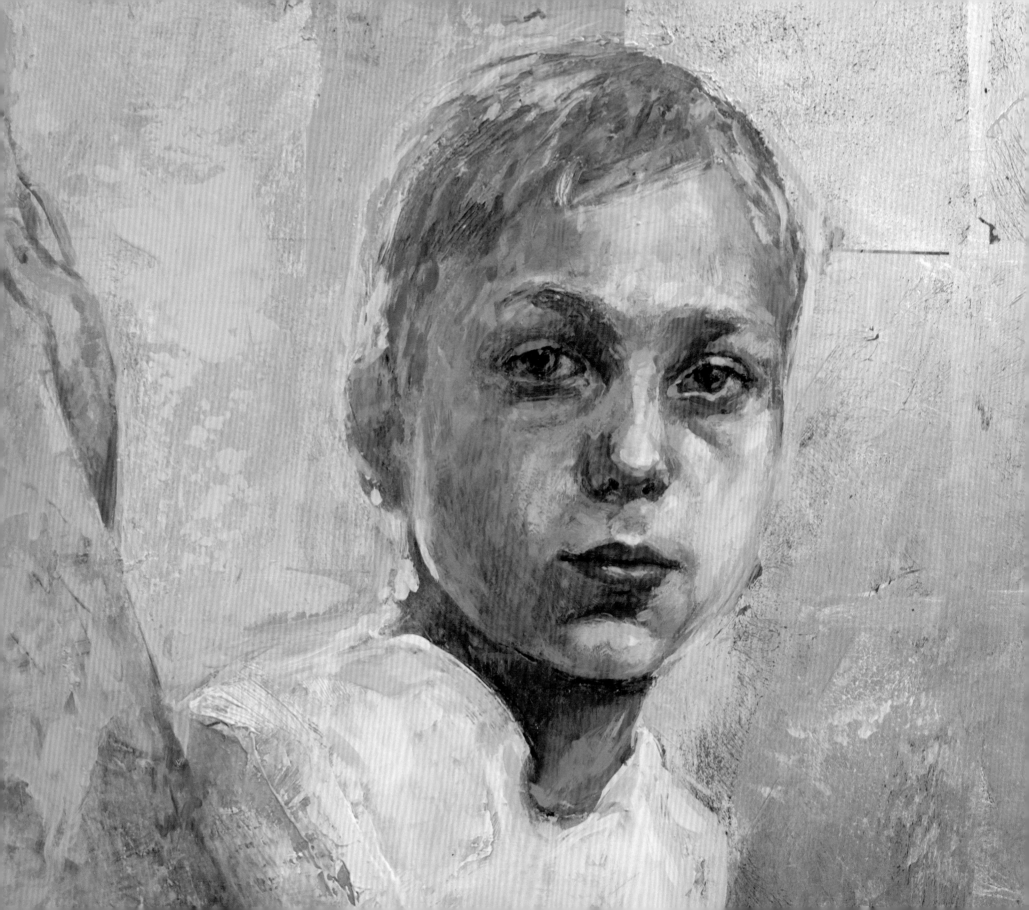

QU4RTETS

fig. 60. detail: *QU4RTETS no.1 (Spring)* © 2012 Bruce Herman; oil with
23kt gold, silver, and moongold leaf on wood; 97" × 60"

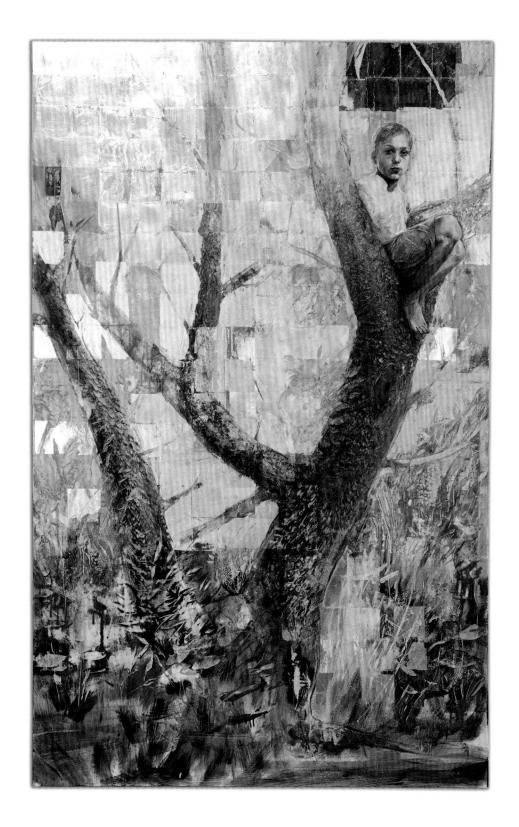

QU4RTETS

[signature: SW Hansen]

T. S. Eliot's "Burnt Norton" (from *Four Quartets*) and Bruce's *QU4RTETS No. 1 (Spring)*

T. S. Eliot invites us into the rose garden of Burnt Norton. When we enter "Through the first gate, / Into our first world" we encounter the presence of others in the garden with us: "There they were, dignified, invisible, / Moving without pressure, over the dead leaves."

In this echo of Milton's account of Adam and Eve—"dignified" and "invisible"—we find that when we enter "our first world" in the rose garden of Burnt Norton, we are in the Garden of Eden. Though our awareness of others in the garden is not grasped by our senses, we meet them, know them, accept them, and dance with them:

> The unheard music hidden in the shrubbery,
> And the unseen eyebeam crossed, for the roses
> Had the look of flowers that are looked at.
> There they were as our guests, accepted and accepting.
> So we moved, and they, in a formal pattern.

Who are "they," "our guests, accepted and accepting"? The answer seems to be that "they" are children: "for the leaves were full of children, / Hidden excitedly, containing laughter." In this encounter with children in our first world, we are "At the still point of the turning world."

In *QU4RTETS no. 1 (Spring)* (fig. 61) Bruce gives us a glimpse of a child in the leaves. When I first looked at him, I wondered how the boy perched on a tree got there. I remember how much fun it

When I first looked at him, I wondered how the boy perched on a tree got there.

fig. 61. *QU4RTETS no. 1 (Spring)* © 2012 Bruce Herman; oil with 23kt gold, silver, and moongold leaf on wood; 97" × 60"

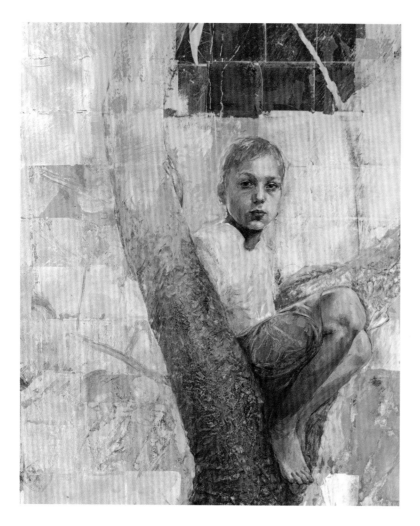

fig. 62. detail: *QU4RTETS no. 1 (Spring)* © 2012 Bruce Herman; oil with 23kt gold, silver, and moongold leaf on wood; 97" × 60"

was to climb a tree when I was a boy his age. I would use that branch on the left as my first step. I could easily skinny up from there to his perch. I laugh, thinking how I sound like Robert Frost: "So was I once myself a swinger of birches. / And so I dream of going back to be."

Now I wonder if the boy on the tree climbed up from earth or came down through that window above him in a shaft of sunlight.

My memory and my laughter pass when I look into the boy's eyes and he looks into mine. Surprised by the depth of that exchange, I become very quiet, listening intently for his words. He seems ready to speak. What will he say? Even though he looks so innocent, I'm sure his words will be filled with wisdom and guide me to know something hidden from me in the ridiculous waste of sad time under all the academic clutter of my life. The prayer of Jesus echoes in my mind: "I praise you, Father, Lord of heaven and earth, because you have hidden these things from the wise and learned, and have revealed them to little children" (Matt. 11:25).

Looking at the boy on a tree fills me with a longing to receive the revelation he has already received from the Father.

The bright green foliage around the tree reveals the new life of spring rising from ground that seemed dead during the long, dark winter. The sky behind the tree reflects a vibrant, glittering light of silver and gold. The tree, though firmly rooted in the earth, disappears through that thin curtain of shimmering light.

Now I wonder if the boy on the tree climbed up from earth or came down through that window above him in a shaft of sunlight. Longing for the wisdom of the boy, I find myself for a moment "at the still point of the turning of the world":

Sudden in a shaft of sunlight
Even while the dust moves
There rises the hidden laughter
Of children in the foliage
Quick now, here, now, always—
Ridiculous the waste sad time
Stretching before and after.

T. S. Eliot's "East Coker" (from *Four Quartets*) and Bruce's *QU4RTETS No. 2 (Summer)*

When I read "East Coker, " I hear an invitation to a dance "In that open field":

If you do not come too close, if you do not come
 too close,
On a summer midnight, you can hear the music
Of weak pipe and the little drum
And see them dancing around the bonfire
The association of man and woman
In daunsinge, signifying matrimonie—
A dignified and commodious sacrament.
Two and two, necessarye coniunction,
Holding eche other by the hand or the arm
Whiche betokeneth concorde.

The archaic spelling tells us that we are invited to watch ancient sacramental dancing (*daunsinge*) joining two lives in matrimony (*matrimonie*). The rhythm of self-giving reciprocity in this sacramental dancing led to the time of coupling of man and woman. By including us in his imaginative vision of an ancient wedding ceremony, Eliot gives us a glimpse of his own

family dancing around the bonfire. Eliot traced his ancestors back to the early 1560s in East Coker. The joy of that dance of his ancestors in the open field was the mirth of those long since "under earth / Nourishing the corn." To the right of the door of St. Michael's Church in East Coker, a plaque bears the inscription of the first and last lines of "East Coker": "In my beginning is my end. . . . In my end is my beginning." Eliot contemplated his own end as he walked through the cemetery of St. Michael's and read the barely legible names of his forebears. His ashes were buried there on January 4, 1965.

Written at the beginning of World War II, as bombs shattered London, "East Coker" contemplates the inescapable darkness of death: "O dark, dark, dark. They all go into the dark." None escape. Eliot lists every category, including

The captains, merchant bankers, eminent men of letters,
The generous patrons of art, the statesmen and the rulers.

On and on the list goes, finally including us:

And we all go with them, into the silent funeral,
Nobody's funeral, for there is no one to bury.

In this unremitting darkness, Eliot takes a strange turn. He goes deeper into darkness:

I said to my soul, be still, and let the dark come upon you
Which shall be the darkness of God. . . .
So the darkness shall be the light, and the stillness the dancing.

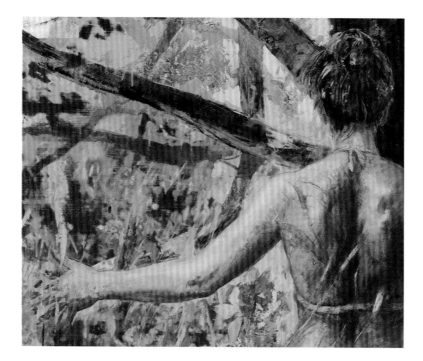

fig. 63. detail: *QU4RTETS no. 2 (Summer)* © 2012 Bruce Herman; oil with 23kt gold, silver, and moongold leaf on wood; 97" × 60"

I read "East Coker" as an invitation to dance in the dark.

When I look at Bruce's painting of the young woman with her back to us (fig. 64), I see a beautiful dancer at the beginning or the end of a dance. She lifts her arms as if she is about to begin or has just ended a twirl with her partner—her form a perfect dancer's form, her hair pinned up. She is dressed, or undressed, for dancing on a summer midnight. She is waiting for the music to start. Or maybe the music has just ended and the dance is over.

Where is her dance partner? Is she waiting for him? Or has he just left? Or maybe he is invisible. The tree seems to be in the

Her fingers disappear into the foliage. Her legs intertwine with the roots. She is one with nature. She was formed from the dust. She will return to dust.

place of her partner. Her arms imitate the form of the branches. Her fingers disappear into the foliage. Her legs intertwine with the roots. She is one with nature. She was formed from the dust. She will return to dust.

Why does her back look so lacerated and scarred? Why has she suffered? Why is she wounded? Her pain did not stop her dance. Her arms are still lifted to receive her partner. Somehow she has Eliot's assurance of the presence of the "wounded surgeon" in her suffering, the surgeon who

> . . . plies the steel
> That questions the distempered part;
> Beneath the bleeding hands we feel
> The sharp compassion of the healer's art
> Resolving the enigma of the fever chart.

The lacerations across her back lead me to Eliot's reminder that the suffering of the cross is the way to recovery and health:

> The dripping blood our only drink,
> The bloody flesh our only food:
> In spite of which we like to think
> That we are sound, substantial flesh and blood—
> Again, in spite of that, we call this Friday good.

fig. 64. *QU4RTETS no. 2 (Summer)* © 2012 Bruce Herman; oil with 23kt gold, silver, and moongold leaf on wood; 97" × 60"

I am not the only one looking at this dancer. Besides the other viewers of this painting, there are eyes of others in the painting. Who are they? They seem to be serious eyes—not eyes of voyeurs, but eyes looking in from another dimension of reality, another time. Are they the dancer's distant ancestors from an ancient time? Or are they her distant children long after her time? Either way, I get the impression that the painting leads us to contemplate the stretches of time long before and long after the time of this young woman. She too will die and join those long since under earth. Maybe she is long gone and this painting gives us a glimpse of her in an ancient time, dancing on a summer midnight. Or perhaps our eyes join with other eyes to see her dancing around the bonfire at the end of all time, her time and our time. "In my end is my beginning."

T. S. Eliot's "The Dry Salvages" (from *Four Quartets*) and Bruce's *QU4RTETS No. 3 (Autumn)*

In "The Dry Salvages" Eliot leads us to meditate on time and the meaning of human experience within time by pointing to the river:

> I do not know much about gods; but I think that the river
> Is a strong brown god—sullen, untamed and intractable.

The river Eliot points to is the Mississippi River, the "strong brown god" that flowed past his childhood home in St. Louis, Missouri. Living on its banks, he heard its rhythm in all stages and seasons of life:

> His rhythm was present in the nursery bedroom,

> In the rank ailanthus of the April dooryard,
> In the smell of grapes on the autumn table,
> And the evening circle in the winter gaslight.

No matter what man does to tame the river by using it for commerce and building bridges across it, the river is

> —ever, however, implacable,
> Keeping his seasons and rages, destroyer, reminder
> Of what men choose to forget.

So it is with time: time is implacable, unstoppable. We are subject to time: "The river is within us, the sea is all about us." Our personal, human time (the river within us) merges with primordial, prehistoric time (the sea all about us).

The woman in *QU4RTETS no. 3* (fig. 65) is submerged in the river; the sea surrounds her. She is in the autumn season of her life when, like the tree behind her, there is "The silent withering of autumn flowers / Dropping their petals and remaining motionless." Her clothing reveals the river within her. Her time, past and present, flows into her time future. In her past there were "Years of living among the breakage / Of what was believed in as the most reliable." But there were also "The moments of happiness—not the sense of well-being, / Fruition, fulfillment, security or affection, / Or even a very good dinner, but the sudden illumination." These were not ordinary moments of happiness, but "beyond any meaning / We can assign to happiness." Such experience "Is not the experience of one life only / But of many generations—not forgetting / Something that is probably quite ineffable."

fig. 65. *QU4RTETS no. 3 (Autumn)* © 2012 Bruce Herman; oil with 23kt gold and silver leaf on wood; 97" × 60"

fig. 66. detail: *QU4RTETS no. 3 (Autumn)* © 2012 Bruce Herman; oil with 23kt gold and silver leaf on wood; 97" × 60"

The woman standing up to her hips in a river of time looks into the future without fear. Her peace comes from those moments of ineffable happiness, "The point of intersection of the timeless

/ With time," when "in a lifetime's death in love, / Ardour and selflessness and self-surrender" she was "lost in a shaft of sunlight . . . or music heard so deeply / That it is not heard at all, but you are the music / While the music lasts." Those moments of "sudden illumination" are "only hints and guesses, / Hints followed by guesses."

Though the river of time with all its "drifting wreckage" flows around and within her, her mind and heart are guarded by peace that passes all understanding (see Phil. 4:6–7). "The hint half guessed, the gift half understood, is Incarnation." That "gift half understood" is a solid rock under her feet, keeping her safe when all around her life is swept away by the rages of the river. She does not look like the "anxious worried women / Lying awake, calculating the future, / Trying to unweave, unwind, unravel / And piece together the past and the future." Her moments of illumination, the "hints followed by guesses," give her a "lifetime's death in love" filled with "prayer, observance, discipline, thought and action."

T. S. Eliot's "Little Gidding" (from *Four Quartets*) and Bruce's *QU4RTETS No. 4 (Winter)*

In this painting an old man looks into my eyes with the same searching gaze of the boy in *QU4RTETS no. 1 (Spring)*. The boy seems to have morphed into the old man as a witness to the

fig. 67. *QU4RTETS no. 4*
(Winter) © 2012 Bruce Herman;
oil with silver leaf and moon
gold leaf on wood; 97" × 60"

recurring line of *Four Quartets:* "In my beginning is my end."
Since the very first time I was caught by the eyes of that old man
in the painting, I felt called by his love and wisdom. He knows
who I am and invites me to . . . what? I did not know.

The old man is between two worlds: a man of solid substance,
standing firmly on the ground and burning my soul with his
wise eyes; yet just behind him is his ghostly aura, as if he stepped
this instant out from the heart of the tree into his embodied
confrontation with me—and just in front of him is the edge
of the picture plane, as if he will step in the next instant into
another world. He has just arrived; he will soon depart.

As I lock eyes with this old sage, I feel I am experiencing Eliot's
encounter with "some dead master / Whom I had known,
forgotten, half recalled / Both one and many; in the brown
baked features / The eyes of a familiar compound ghost / Both
intimate and unidentifiable." What would be my dialogue
with my dead masters if I met them in the "waning dusk," all
combined in a "familiar compound ghost"? I do not suppose I
could easily endure such an encounter. It might well mean the
end of me, but also a new beginning.

The stern words of Eliot's dead master disclose "the shame / Of
motives late revealed, and the awareness / Of things ill done
and done to others' harm / Which once you took for exercise of
virtue. / Then fools' approval stings, and honour stains." These
words burn to the core, and yet I know there is no hope "unless
restored by that refining fire." Ah, I thought this encounter
would be painful, and I was right.

But though his wise eyes see my selfish motives behind all my
facades, his eyes also give me hope:

> And all shall be well and
> All manner of thing shall be well
> By the purification of the motive
> In the ground of our beseeching.

Eliot quotes Julian of Norwich, a mystic in the fourteenth
century. Julian taught that "beseeching is a true and gracious
enduring will of the soul united and joined to our Lord's will by
the sweet, secret operation of the Holy Spirit." Eliot applies her
teaching by pointing to the purifying fire of the Holy Spirit:

> The dove descending breaks the air
> With the flame of incandescent terror
> Of which the tongues declare
> The one discharge from sin and error.
> The only hope, or else despair
> Lies in the choice of pyre or pyre—
> To be redeemed from fire by fire.

My confrontation with the old man leads to a choice of "pyre or pyre." In Eliot's words, "We only live, only suspire / Consumed by either fire or fire." Either our lives will be consumed by the infernal fire of greed, rage and lust, or by the eternal fire of redemptive love. Through the fire of the "dove descending," all the works of our impure motives are burned to ashes, but through death we are reborn. "We are born with the dead: / See, they return, and bring us with them."

Now I see that the old man's eyes are inviting me to join him as he moves into the world off the picture plane. He has moved through death to rebirth. He calls me to do the same. I have a choice to make: will I choose to be consumed by the power of consumerism? Or will I choose to be purified by the fire of the dove descending? That would be the end and the beginning, "Costing not less than everything."

> What we call the beginning is often the end
> And to make an end is to make a beginning.
> The end is where we start from.

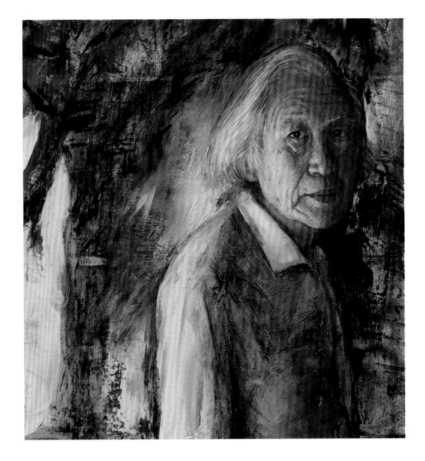

fig. 68. detail: *QU4RTETS no. 4 (Winter)* © 2012 Bruce Herman; oil with silver leaf and moon gold leaf on wood; 97" × 60"

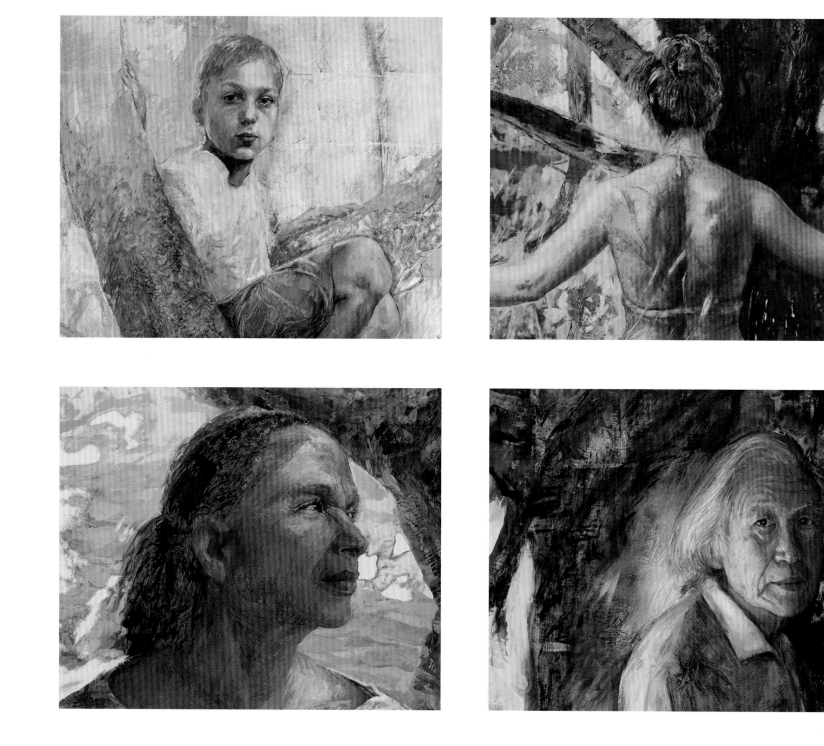

Chapter 13

QU4RTETS

B. Herman

The chance to collaborate with other artists is relatively rare for me, and in the *QU4RTETS* project I have had an ideal set of artistic collaborators: my friend and co-writer Walter Hansen, who helped jump-start the whole project at dinner one night (and subsequently provided generous initial funding for a touring exhibit and book); painter Makoto Fujimura and composer Christopher Theofanidis—both highly accomplished artists whose insights can be found all over my work; and theologian Jeremy Begbie weighing in as a dialogue partner, essayist, and convener of a major seminar around our project at Duke University, winter 2013. Together we have begun a rich enterprise generating paintings, musical composition, and multifaceted conversation with poetry, theology, and art.

We have all taken the same text as a departure point—T. S. Eliot's great work *Four Quartets*. This four-part poem was composed between 1936 and 1942, published initially as separate texts during the years leading up to and during WWII. The last section, "Little Gidding," was penned during the Blitz in London. The final unified form of the poem was not seen publicly until 1943, when Eliot's American publisher, Harcourt, brought it out as a single volume. Since that time the poem has grown to be seen as a major milestone in Western literature; and though not without its controversy in academic circles, it has enjoyed global acceptance as a masterpiece.

Our own interaction and production of paintings, text, and musical composition have been generated largely by our conversation surrounding Eliot's poem—and around our shared Christian faith and sense that *Four Quartets* is a true masterwork of art and theology. My own contribution to the project (reproduced in fig. 60–69 on pages 98–112) developed over the course of 2011 and 2012. In these large paintings I've tried to reflect on some of the same material that Eliot was trying to get at—the spiritual maturation of the soul and the "point of intersection of the timeless / With time" ("Dry Salvages" 5.201–2). I've also self-consciously participated in the tradition in Western art

I've also self-consciously participated in the tradition in Western art of depicting the four seasons, the four medieval elements (earth, air, fire, and water), and the four stages of life.

fig. 69. details, clockwise from top left: *QU4RTETS no. 1 (Spring)*, *QU4RTETS no. 2 (Summer)*, *QU4RTETS no. 4 (Winter)*, *QU4RTETS no. 3 (Autumn)* © 2012 Bruce Herman; oil with 23kt gold, silver, and moongold leaf on wood; 97" × 60"

of depicting the four seasons, the four medieval elements (earth, air, fire, and water), and the four stages of life. The mysterious "fifth element" (the aether) was believed by the ancients to be the "glue" that held all things together—literally known as the quintessence—and by medieval Christians it was associated with Christ: "through whom all things were made; in whom all things hold together" (Col. 1:16–17). My attempt to evoke this fifth element was through extensive use of gold and silver and moon-gold leaf—applied much the same way it has been since the earliest Byzantine times.

In a very real sense, the gold becomes for me a symbol of God's presence in the images; but it is certainly not meant to end with that, my own interpretation. As Walter writes elsewhere in this volume, the artist's interpretation, though originating, is not final. In fact, it is my sincere hope that others will find additional meaning and satisfaction in these images beyond what I've narrowly intended. For that is the ultimate nature of art and poetry—to open out again onto this world and its many

mysteries. Again, I'm not at all interested in simply making visual arguments or veiled "messages" in paint. I am prompted to explore and attempt to discover new ground while building a bridge with existing traditions.

One last thought to share on this series and on our entire book project: if the reader and viewer take nothing else away from *QU4RTETS* or this conversational book than that they receive a sense of welcome, a summons even to enter into dialogue with art and artists in the church, then it will have been worth all the work and expense. My collaboration with Makoto Fujimura and Christopher Theofanidis on *QU4RTETS* in response to Eliot's poem has yielded powerful music and painting—and we sense that the generative qualities of this text will continue to bear fruit in generations to come. Our hope is that our own work, too, may offer some small contribution to that larger body of culture making which seeks the same insight and beautiful form that T. S. Eliot strove to achieve.

Postscript

The authors have attempted to include you, the viewer and reader, in our ongoing conversation about art and faith—and we have tried to model what we feel is that "excess of meaning" referred to in the early Rowan Williams quotation. The deepening mystery and meaning—the reality that art is more than what the artist conceives and creates—can be experienced only by a participant, not by a passive consumer. That is why we have written this book—an extended meditation and invitation to you to enter with us into the larger conversation of tradition, of faith, of art as culture making. The shared vision and excess of meaning that art can offer is only possible when we're willing to suspend disbelief and accept the invitation to the dance. And as T. S. Eliot said, "There is only the dance."

Timeline

1982

Boston Studio (with painting: *Portrait of William Harsh*)

1989–90

Man and Machine series

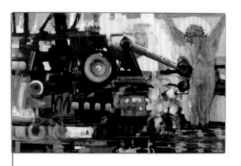

1996–97

Lanesville Murals

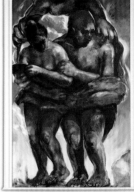
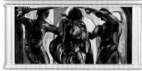

1985–89

Dream of Wet Pavements series

1991–93

Golgotha series

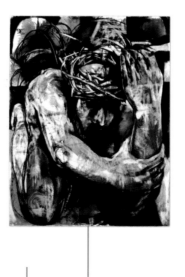

1997

HOUSE/STUDIO FIRE
studio work ceases

1990

1999–2001

Building in Ruins series

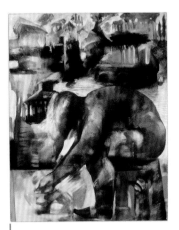

2005–07

Magnificat altarpieces

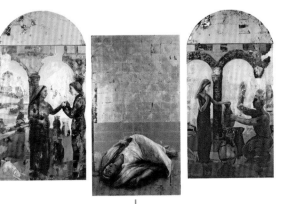

2008–10

Presence/Absence series

2002

Body Broken series

2006

Woman series

2010–12

QU4RTETS series

2000

2010

At the still point of the turning world. Neither flesh nor fleshless;
Neither from nor towards; at the still point, there the dance is,
But neither arrest nor movement. And do not call it fixity,
Where past and future are gathered. Neither movement from nor towards,
Neither ascent nor decline. Except for the point, the still point,
There would be no dance, and there is only the dance.

(from "Burnt Norton," *Four Quartets*, T. S. Eliot)

Contributors

Bruce Herman is a painter who lives and works in Gloucester, Massachusetts—home and haven to many artists and poets over the past two centuries: Fitz Henry Lane, Winslow Homer, T. S. Eliot, Charles Olson, Edward Hopper, Marsden Hartley, and many others. Herman's art is exhibited worldwide, and is represented in many public and private collections, including the Vatican Museum of Modern Religious Art, the Cincinnati Museum of Art, the Grunwald Print Collection at the Hammer Museum in Los Angeles, the deCordova Sculpture Park and Museum near Boston, and many university and college collections nationwide.

Bruce has taught painting at nearby Gordon College for three decades, and in 2006 received the first fully endowed professorship there, the Lothlórien Distinguished Chair in Fine Arts. He is currently curator for the Gordon College art gallery at Barrington Center for the Arts.

G. Walter Hansen is a writer, biblical scholar, and philanthropist whose sojourn has taken him all over the world in teaching tours and ministry. His writings on New Testament books such as Philippians and Galatians are a staple of scholars and preachers. His philanthropic interests include works in India, Africa, the Balkans, and many other lands. He and his wife, Darlene, are supporters of the arts as well, and their friendship with Bruce has been a fruitful exchange that has enabled the artist to flourish and produce many of his most important works in the past decade.

Acknowledgements

We would like to thank the following persons, without whose help in the reading and preparation of this book we could never have brought this project to completion:

Roger Lundin, Arthur F. Holmes Professor of Faith and Learning, Wheaton College

Cameron Anderson, Executive Director of Christians in the Visual Arts (CIVA)

Gregory Wolfe, Writer in Residence, Seattle Pacific University, and founder editor of *IMAGE* Journal

Joel Sheesley, Professor of Art, Wheaton College

Theodore Prescott, Professor of Art Emeritus, Messiah College

Stan Gaede, Scholar in Residence, Gordon College

Patty Hanlon, Editor of *Stillpoint* Magazine, Gordon College

Bill Eerdmans, President and owner of William B. Eerdmans Publishing Company

Sandra de Groot, Senior Editor, William B. Eerdmans Publishing Company

and to our beloved families for their loving support and belief in this project.

Old men ought to be explorers
Here or there does not matter
We must be still and still moving
Into another intensity
For a further union, a deeper communion
Through the dark cold and the empty desolation,
The wave cry, the wind cry, the vast waters
Of the petrel and the porpoise. In my end is my beginning.

T. S. Eliot, "East Coker"